POSTCARD HISTORY SERIES

Corona

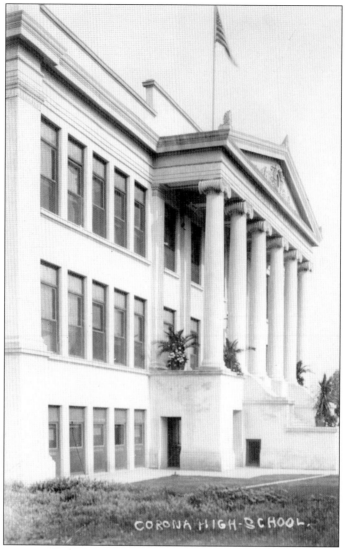

CORONA HIGH-SCHOOL.

FIRST CORONA HIGH SCHOOL, C. 1908. Due to extreme overcrowding at the only school in town, this building, designed by F. P. Burnham in the classical Revival style, was built by local contractor Leo Kroonen Sr. for $31,589. The facilities were considered to be state of the art when 65 students entered in September 1907. This magnificent two-story school with a basement was located in the 1200 block of Main Street where Corona Fundamental Intermediate School is found in 2006. (Courtesy author.)

ON THE FRONT COVER: CORONA EXHIBIT AT NATIONAL ORANGE SHOW IN SAN BERNARDINO, FEBRUARY 1913. Seven months prior to Corona's first road race on September 9, 1913, this display, made mainly of oranges, advertises the inaugural event. (Courtesy D. Williamson.)

ON THE BACK COVER: PROMOTIONAL POSTCARD FOR 1913 CORONA ROAD RACE. Residents of Corona mailed brightly colored postcards far and wide to encourage family and friends to descend upon the Circle City for its first speedfest. The use of the unique circular Grand Boulevard as the race track made the event truly one of a kind. (Courtesy D. Talbert.)

POSTCARD HISTORY SERIES

Corona

Mary Bryner Winn

ARCADIA
PUBLISHING

Published by Arcadia Publishing
Charleston SC, Chicago IL, Portsmouth NH, San Francisco CA

Printed in the United States of America

Library of Congress Catalog Card Number: 2006926312

For all general information contact Arcadia Publishing at:
Telephone 843-853-2070
Fax 843-853-0044
E-mail sales@arcadiapublishing.com
For customer service and orders:
Toll-Free 1-888-313-2665

Visit us on the Internet at www.arcadiapublishing.com

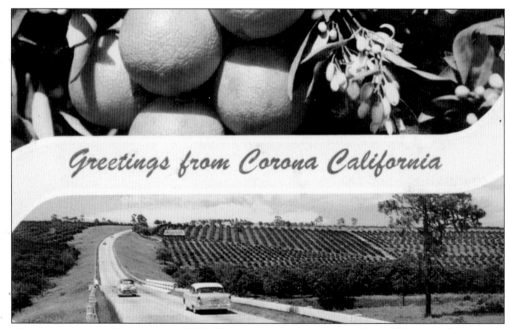

GREETINGS FROM CORONA, C. 1955. Bounteous citrus crops and beautiful pastoral scenes are what Corona was known for in past decades. Although oranges are pictured in this postcard, Corona was once referred to as the "Lemon Capital of the World" because more lemons were shipped from Corona than anywhere else. (Courtesy D. Talbert.)

CONTENTS

ACKNOWLEDGMENTS

First of all, I'd like to thank the many publishers who produced postcards of Corona beginning over a century ago.

The completion of this book was a team effort due in large part to the ongoing support of my family. Encouraging me all the way were my husband Richard, son Blaine, and daughter Margaret Jayne. The assistance of and cheering on by special friends Lisa Swank, Jill ZamEk, and Mary Jo Boller has been invaluable.

I wish to express my sincere appreciation to those who generously shared their collections of precious vintage postcards with me: Noella Benvenuti, John Farr, Raymond Harris, Steve Lech, Eugene Montanez, Darrell Talbert, and Don Williamson. Classic postcards were also made available from the archives of the W. D. Addison Heritage Room and were used by permission of the board of trustees of the Corona Public Library. Many thanks go to Chris Tina Smith, Jennifer Marlatt, Vera Garcia, and Theresa Hodges from the Library's Heritage Room for their help while using the archives and answering my questions.

Special thanks go to my dear friend and longtime Corona resident Raymond Harris for spending many hours with me sharing his wonderful memories, wit, and wisdom. Friends Phil Newhouse, Kathleen Dever, Nancy Gutierrez, and Kevin Bash also provided insight and information to enrich the content of my captions.

The ongoing support of my friends and colleagues in the Corona Historic Preservation Society is very much appreciated as well.

INTRODUCTION

Corona is found in western Riverside County approximately 45 miles southeast of Los Angeles close to the southeastern edge of San Bernardino County and the northern edge of Orange County. It has grown by leaps and bounds for over 120 years to be the commercial hub of western Riverside County in 2006.

Luiseño Indians were the first inhabitants of the region and lived in the Temescal Canyon near the area now known as the Glen Ivy Spa. The Luiseños later befriended Spanish settlers in the area. Leandro Serrano was the first of the Spanish settlers to enter the canyon and establish a rancho in 1818. Juan Bandini established a cattle and sheep ranch in the Prado area in 1838. This was northwest of what was later to be called Corona.

Robert B. Taylor, from Sioux City, Iowa, visited the area in the mid-1880s. The climate was recognized as exceptional and water sources were nearby in Temescal Canyon. He set about to convince four other speculators in Iowa to join him in establishing a colony on the barren, desert-like plain. Taylor's vision was to transform the area into a thriving yet unique community. His novel idea was to create a town surrounded by a circular roadway, one mile in diameter, a little over three miles in circumference, and 100 feet wide.

Taylor persuaded several of his fellow Iowans to join him in this business venture. They formed the South Riverside Land and Water Company, which covered 12,000 acres of undeveloped agricultural land purchased from Spanish ranchos. They brought water to South Riverside (or The Queen Colony, as it was dubbed) via ditches, pipes, and wells to permit cultivation of the land and to provide sustenance to newly planted citrus trees and other crops. They brought in other specimen trees, shrubbery, and grass to transform the rock-strewn, brush-covered plain and fill it with homes, businesses, churches, and schools.

The community was founded as South Riverside in 1886, but 10 years later the residents voted to incorporate and change the name to Corona. And so it remains today, 110 years later.

The Santa Fe Railway Depot opened in 1887 to provide an arrival point for visitors and new residents and a shipping point for the citrus crops to markets all over the world. Packinghouses appeared alongside the tracks to accommodate the millions of tons of citrus fruit being prepared for shipment abroad. Businesses cropped up inside the "circle" to provide for residents' needs.

In 1913, 1914, and 1916, city leaders took advantage of the popularity of automobile racing and offered up the circular Grand Boulevard as a world-class, auto-racing venue. The events were intended to acquaint visitors with the city and attract new residents. These three days, when world speed records were broken, put Corona on the map.

With a strong agricultural economy, Corona suffered less from the ravages of the Depression than other communities. During the 1940s and 1950s, the financial system became more diversified although agriculture continued to be the backbone of the economy.

The 1960s and 1970s were pivotal as population increased, the State Route 91 freeway provided greater access to the Inland Empire, and urban renewal of the downtown took place.

With record-breaking new housing construction and the completion of the I-15 freeway during the 1980s and 1990s, the population skyrocketed again. By 2000, Corona was reclassified from a rural area to a midsize urban community. Our forefathers could never have imagined what a thriving community Corona would become.

The postcards found within the pages of this book are some of the only glimpses left of scenes that once existed in the Circle City. They are not only visually interesting, but they whisper tales from Corona's past. Postcards are a marvelous way to learn history and are tangible glimpses of the life and times of the past. When early postcards were written, the writers never anticipated that decades, or even a century later, the pictures and their written messages would be recognized as important historical resources.

Similar to today's e-mail and text messaging, postcard writings were brief notes that were inexpensive to send. Some were written in stream-of-consciousness style with little or no capitalization or punctuation, and many used abbreviations. They were sent with ease, and this contributed to their popularity. Postcard pictures were often carefully selected and were meant to be visually pleasing and interesting. They provided a way for senders to show off their hometowns or places they visited while traveling.

The "Golden Age" of postcards was from 1898 to 1918. Americans went wild for picture postcards, and collecting these depictions of life was a grand hobby. The majority of postcards sold in the U.S. were printed in Germany where lithography was already an art. World War I, however, caused a decline in the hobby when the supply of postcards from Germany came to an end. Poorer quality postcards came from U.S. publishers. Lowered quality of the printed postcard, recurrent influenza epidemics, and World War I shortages diminished the American postcard hobby.

During the World War I years, telephone calls replaced the postcard as a fast, reliable means to keep in touch, and telegrams were used to transmit short messages on paper. Movies replaced photographs and postcards as a source of visual experiences. Nevertheless, postcards continue to be used today for the same purposes as in days past—to communicate with ease and to provide enjoyment for the recipient.

During the height of the popularity of postcards, Coronans also participated in this splendid tradition. During this era, local drugstore owner Rufus Billings printed postcards and sold them for a penny from his establishment on Main Street. Postcards of Corona's past reflect a humble, hardworking population. Early inhabitants of Corona survived floods, snowstorms, frosts, water shortages, and a host of other trials and tribulations, some of which were recorded on postcards. The images are of thriving commercial locations, lemon and orange groves, churches, hotels, schools, well-maintained homes on tree-lined streets, special occasions, the few extravagant residences, other points of interest, and, of course, the colorful history of the Corona Road Races.

When reviewing vintage Corona postcards, one can observe some interesting details. In addressing postcards during the early 20th century, it was common for only the addressee and the city to be named. Obviously the town's population was small enough that all were familiar with where each other lived. Elaborate handwriting was used in an era when penmanship was a disciplined art form. Messages were typically written with fountain pen or pencil since ballpoint pens did not become widely available until the 1940s. Topics most often mentioned included being homesick, ailments or "sick spells," details about the weather, the sender's traveling plans, and apologies for either not writing a lengthy letter or for not writing sooner. Postcards were also sent to others to recognize special events such as birthdays or holidays.

It is hoped that as the sights within these pages are reviewed, they will bring back memories to longtime local residents as well as introduce the rich heritage of Corona to a new generation.

One

SCENIC STREETS IN THE CIRCLE CITY

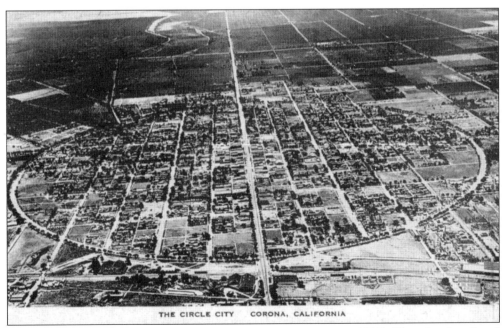

THE CIRCLE CITY CORONA, CALIFORNIA

BIRD'S-EYE VIEW OF CIRCLE CITY LOOKING SOUTH, C. 1927. The circular Grand Boulevard provides a unique sight from an aerial view. City founders wanted South Riverside, Corona's original name, to stand out from other communities founded during the "Land Boom of the 1880s." Many colonies were established but not all survived from that era. Corona's first Victorian-style Santa Fe Depot is seen in the foreground. (Courtesy D. Williamson.)

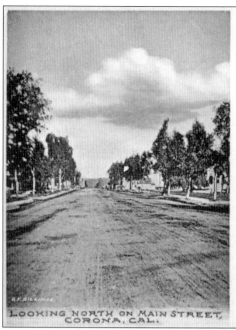

MAIN STREET LOOKING NORTH TOWARD EIGHTH AND MAIN STREETS, 1908. By federal law, writing was not permitted on the address side of postcards until March 1, 1907. This is why the blank area is provided on the picture side. Windows on the south side of the Carnegie Library can be distinguished behind the trees on the right. Beyond that, Corona's first fire station is the small building with a dark roof in the center of the image. (Courtesy author.)

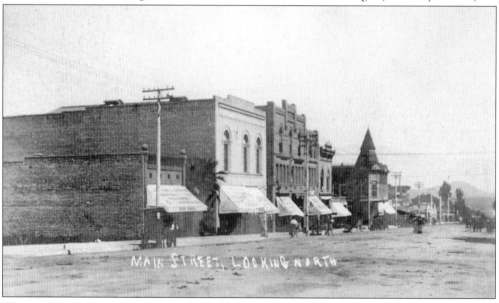

MAIN STREET, LOOKING NORTH.

WEST SIDE OF MAIN STREET, C. 1908. "James L. Davis furniture, wallpaper, window glass, picture frames" is found on the first awning to the left. The second awning, which is on the Masonic Temple, reads "baths, drugs." The space between the temple and the next building, the Southern Hotel, was known as "Pigeon Pass," a very narrow alley. Citizen's Bank with its witch-hat cupola and Beacon Hill are seen in the background. (Courtesy D. Talbert.)

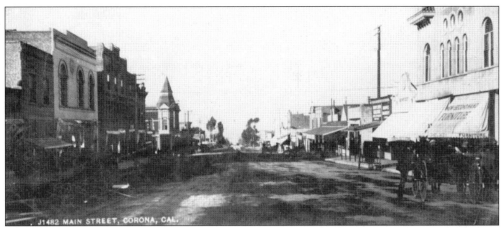

LOOKING NORTH ON MAIN STREET, EARLY 1909. A panoramic view of downtown is seen on this wider postcard. Clearly discernible on the right are James L. Davis New Secondhand furniture, Corona Department Store, the Bonfoey Building, and Home Bakery. Decades later, the two buildings under the large shed roof were relocated to a spot north of the freeway, converted to apartments by C. W. Harris, and are still inhabited today. Note the hitching posts along the curb. (Courtesy D. Williamson.)

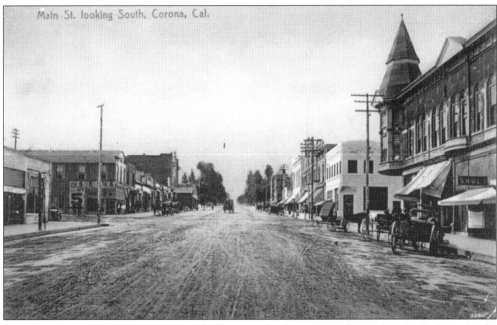

MAIN STREET LOOKING SOUTH, C. 1910. Many businesses were located on Main Street in the early years. The curbs were placed in 1898, but streets have not yet been paved here. Citizen's Bank is on the right along with a shoe store, Frank Geith's Market, Corona National Bank, Bonfoey's Bakery, and Corona Hardware. The rounded cupola of the Lord Building is seen in the distance on the right behind the third lower pole. Horseless carriages await drivers and packages acquired by busy shoppers making the rounds downtown. (Courtesy D. Williamson.)

11

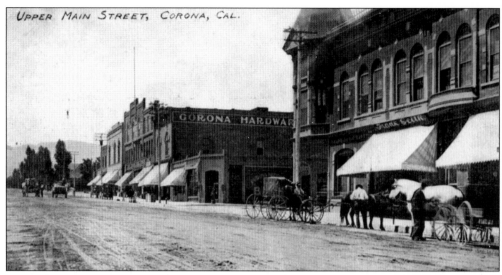

UPPER MAIN STREET, CORONA, CAL.

WEST SIDE OF MAIN AT SIXTH STREET, 1910. This unpaved roadway was dusty during the dry season and muddy when it rained, making it a challenge for ladies to keep their skirt hems unsoiled. Pictured here, from left to right, are the Masonic Temple building, the Southern Hotel, Corona Hardware, a one-story Corona National Bank, Citizen's Bank, and Frank Geith's Market. The original First Baptist Church is seen among trees in the distance. The handwritten message is found below. (Courtesy author.)

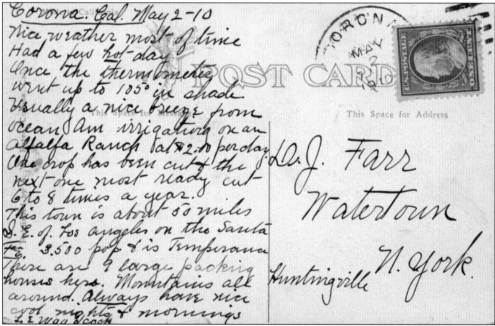

IN THEIR OWN WORDS. "Nice weather most of time Had a few hot days Once the thermometer went up to 105 degrees in shade Usually a nice breeze from ocean Am irrigating on an alfalfa ranch At $2.00 per day One crop has been cut & the next one [al]most ready cut 6 to 8 times a year. This town is about 50 miles S.E. of Los Angeles on the Santa Fe. 3,500 pop[ulation] & is Temperance. There are 9 large packing houses here. Mountains all around. Always have nice cool nights & mornings." (Courtesy author.)

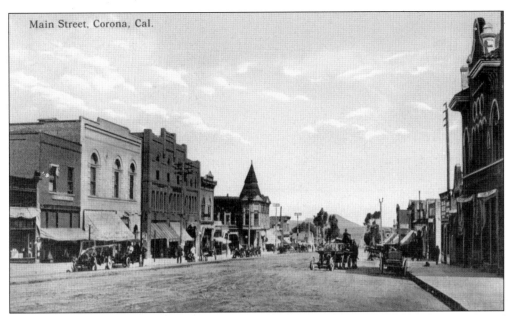

Main Street, Corona, Cal.

MAIN STREET LOOKING NORTH, 1913. Streetlights and power poles line the streets of Corona's commercial center. The Odd Fellows Hall is on the right. The Masonic Temple is the second building on the left. During the 1920s, the lower floor housed a theater managed by the Nutters, who also ran another theater on East Sixth Street. Movies were shared between both theaters by transporting the reels during intermission. (Courtesy D. Williamson.)

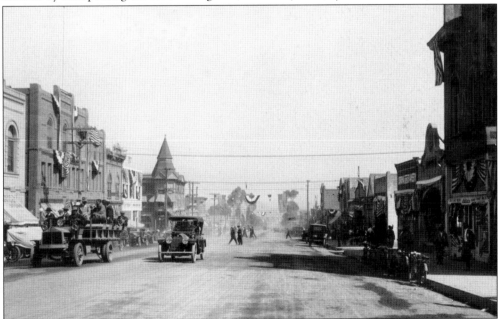

DOWNTOWN ON ROAD RACE DAY, MID-1910s. Buildings on Main Street are festooned with patriotic bunting and American flags, while men wear tickets for entry to the races on their lapels. Murray's Drug Store is seen on the far left. On the far right is Adler's, where "only the best has the best" is written above the door. Corona welcomed crowds of up to 100,000 to the Corona Road Races of 1913, 1914, and 1916. (Courtesy author.)

13

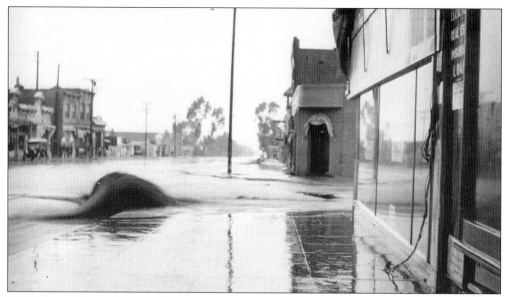

SIXTH AND MAIN STREET LOOKING SOUTH. On January 27, 1916, five inches of rain fell in less than 20 hours, causing streets to flood. During this flood, the Temescal Wash became a raging river and the Santa Fe tracks just north of the Grand Boulevard Circle were washed out. California's governor, Hiram Johnson, his party, and 120 others were stranded in Corona for three days. They were on their way from San Diego to Los Angeles when floodwaters isolated the city. (Courtesy Corona Public Library.)

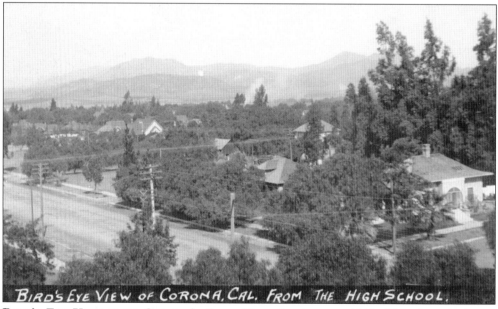

BIRD'S-EYE VIEW FROM CORONA'S FIRST HIGH SCHOOL, C. 1910. This photograph was taken from the roof of the school looking northeast. The intersection is South Main Street and Grand Boulevard. A doctor occupied the white house on the corner. The Woman's Improvement Club had not yet been built in the field at the southeast corner of Eleventh and Main Streets. The white building left of center is the south side of the Methodist church. (Courtesy author.)

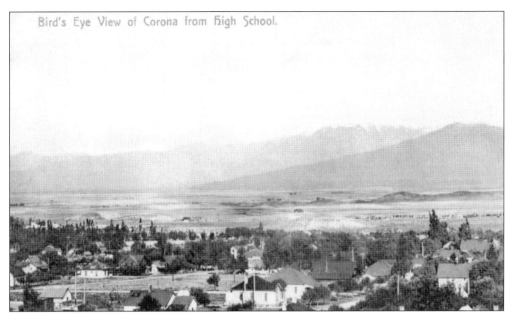

ANOTHER BIRD'S-EYE VIEW, C. 1908. Here the camera is directed in a southeasterly direction toward El Cerrito. The postmark read July 29, 190?. The last digit of the year was obliterated when the postage stamp was removed. The message on the back reads, "Dear Miss Hancock—Didn't you tell me I'd roast up here? I've been wearing a sweater and a coat for three days. Am getting well acquainted with rattlesnakes." (Courtesy D. Talbert.)

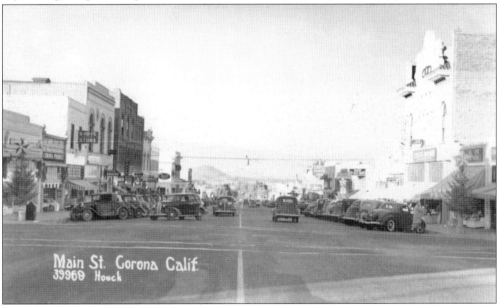

Main St. Corona Calif.
39969 Houck

MAIN STREET LOOKING NORTH FROM SEVENTH STREET, 1930S. The light suspended by wires in the center was used to summon police. When the red light was turned on, a nearby phone in a call box at the southwest corner was used to reach the police station. Businesses on the left were a bakery, shoe store, and Rexall Drugs. Those on the right were Bogel's Dollar Store, Schmidt's market, Alpha Beta market, a pool hall, Stanfield's Bakery, Cut Rate Drugs, and C. W. Harris and Son. (Courtesy D. Williamson.)

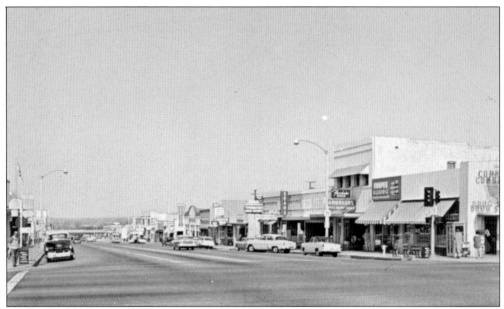

MAIN STREET LOOKING NORTH, EARLY 1960S. Business establishments viewed on the right side of Main Street are Cunning's Drug Store, Corona Electric, Emerson's Men's Wear (which sold Florsheim Shoes), Robinson Benedict Stationery Store, Sears Catalog Store, Mode O'Day dress shop, a liquor store, and a furniture store. The Riverside or State Route 91 freeway opened to traffic in 1961. (Courtesy author.)

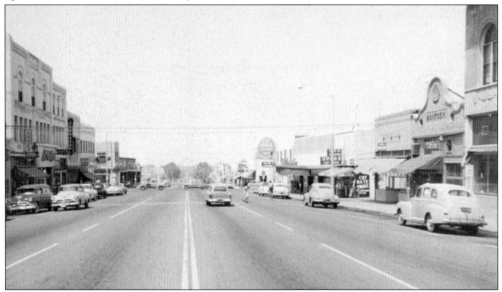

MAIN STREET LOOKING NORTH, C. 1959. Pictured on the left side of Main Street, from left to right, are a shoe store, Kristy's dress shop, Hemphill's Furniture, Corona Drugs, First National Bank, Juanita's dress shop, and a barbershop. On the right are a barbershop and pool hall in the Bonfoey Building, Cut Rate Drugs, Bowen's Bakery, C. W. Harris and Son, Bank of America, and Cunning's Drug Store. The sender wrote, "I don't see why you old cronies don't make a trip before you have to come in a wheelchair. You have no kids to leave your millions to. Ha ha." (Courtesy author.)

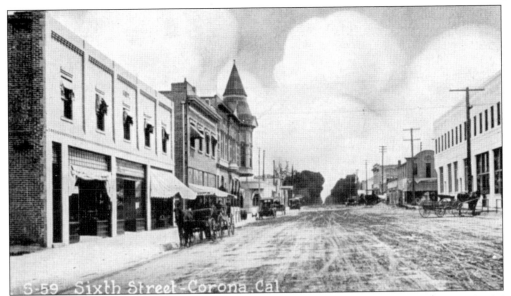

LOOKING EAST ON SIXTH STREET FROM WASHBURN. In this early 1900s photograph, the Citizen's Bank is on the left, and Corona National Bank is on the right. A 1915 ad for the latter in the *Corona Courier* reads, "Information and advice cheerfully given on all matters relating to the financial affairs of its patrons." The Featherstone Building, with its arched roof, is seen at the southeast corner. Street improvements appear to be taking place, evidenced by two piles of road-surfacing materials. Note the hitching posts on the right. (Courtesy author.)

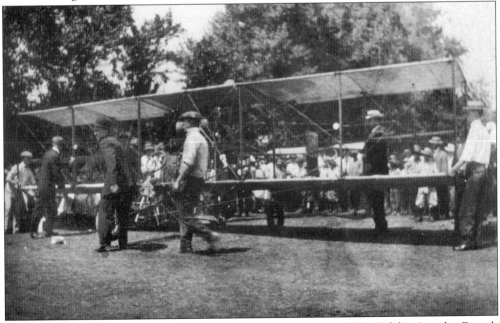

BIPLANE PREPARING FOR TAKEOFF ON EIGHTH STREET, 1915. Celebrating the Fourth of July, a curious crowd is present to watch the takeoff of the double-winged aircraft. The location is thought to be on Eighth Street between West Grand Boulevard and Lincoln Avenue. This area was open space at one time and was the location of a variety of circuses and rodeos over the decades. (Courtesy Corona Public Library.)

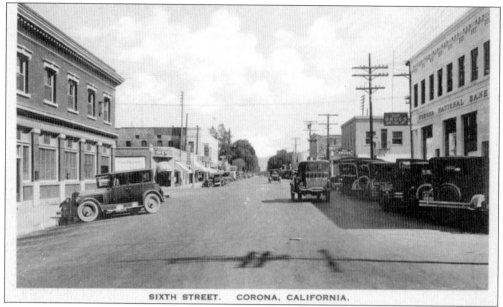

SIXTH STREET. CORONA, CALIFORNIA.

LOOKING EAST ON SIXTH STREET FROM BELLE, 1930S. To the left, the witch-hat cupola has been removed from Citizen's Bank, which merged with First National Bank at an earlier date. The wording on buildings to the right read confectionery, soda, drugs, real estate, and Kinney Café. Corona National Bank is pictured on the right with a Rexall Drugs sign. Across the street is another—a total of three drugstores at the intersection of Main and Sixth Streets. Note the diagonal parking and power poles. (Courtesy author.)

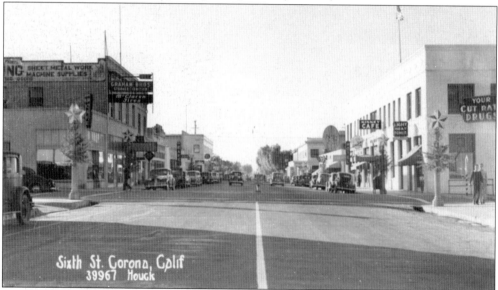

Sixth St. Corona, Calif
39967 Houck

SIXTH STREET LOOKING EAST FROM RAMONA, C. 1940. Businesses on the left of Sixth Street, from left to right, are an optometrist, Glass Brothers Hardware, Home Telephone Company, Keller's Furniture, and Harter's liquor store. The arrow above the second-story sign on the left points to Graham Brothers Garage, located at Ramona Avenue and Seventh Street. On the right side of Sixth Street are Cut Rate Drugs; the Light, Heat and Power office; Kinney Hotel and Café; Mava Ice Cream; Cunning's Drugstore, and First National Bank. (Courtesy D. Williamson.)

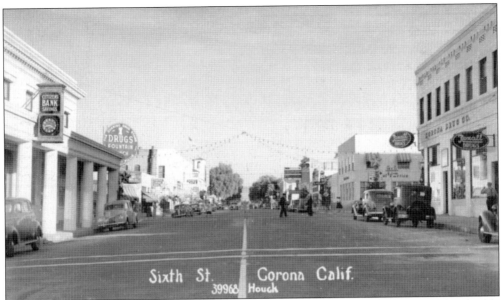

LOOKING EAST ON SIXTH STREET FROM BELLE, *C.* **1940.** Here a portico has been added to Citizen's Bank to strengthen the building. Many residents relied on the large clock to set their watches, and the wording on the clock reads, "Citizen's Bank Savings." The tower of the Corona Theater is slightly left of center, Corona Drug Company is on the right with the Bank of America, and on the center line of the roadway is a rectangular stop sign. (Courtesy D. Williamson.)

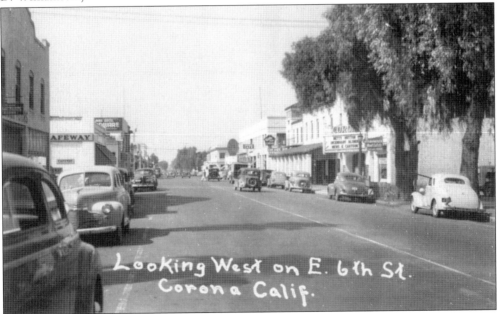

LOOKING WEST ON EAST SIXTH STREET NEAR RAMONA AVENUE, *C.* **1945.** Above the Mission Garage, left, are the Mission Apartments. The Safeway market is the second building from the left, and on the right is the Corona Theater, now known as the Landmark Building. Featured on the marquee is *An Incendiary Blonde*, featuring Betty Hutton. According to an online review, the film is about "the life of a boisterous entertainer." (Courtesy D. Williamson.)

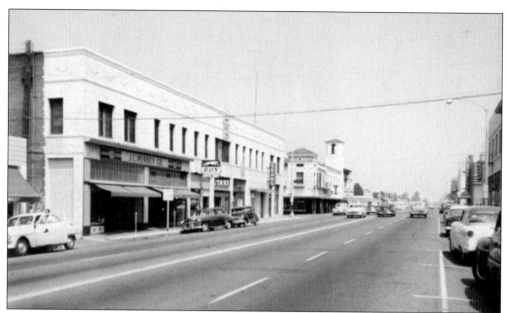

Looking East on Sixth Street toward Ramona, 1955. Rooms for Hotel Kinney are located on the second floor of the building to the right. Lodgers entered the lobby through a door near the taxi sign. Occupants on the first floor are JCPenney, the Greyhound bus office, and the Sears catalog store, which once served as the post office. The Corona Theater, with its distinctive tower and architecture, is across Ramona Avenue. (Courtesy D. Williamson.)

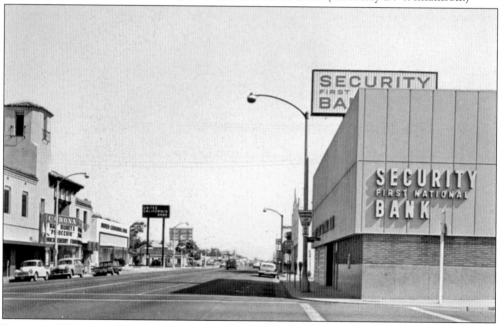

Looking East on Sixth from Ramona, 1964. The Corona Theater, featuring Walt Disney's *Pinocchio*, stands on Sixth Street along with United California Bank, a Chevron station, and a Shell station. On the right is Security First National Bank, which serves as the downtown Bank of America in 2006. The next large building on the right is the Mission Apartments. Taller streetlights are now in place along Sixth Street. (Courtesy author.)

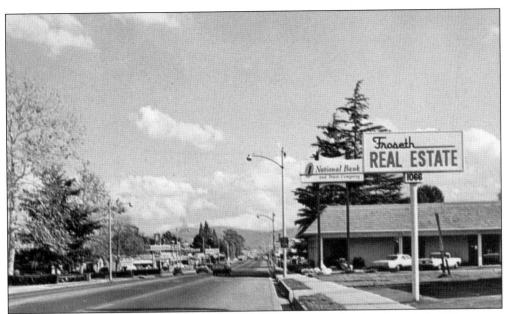

LOOKING EAST ON SIXTH STREET FROM LINCOLN AVENUE, 1960s. Froseth Real Estate was owned by Hilbert I. Froseth, who served on the Corona City Council and was mayor in 1966. The First National Bank and Trust Company building is now home to Pacific Western Bank. Homes are seen on the north side of Sixth Street. Trees on the right in the distance indicate the location of Corona's second high school at 815 West Sixth Street. (Courtesy D. Williamson.)

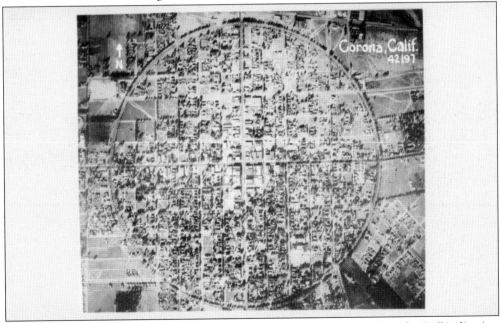

AERIAL VIEW, 1940s. The Washington School campus is located just below the "N" indicating north at the top of the postcard. Clearly discernible are commercial establishments located in the center where Main and Sixth Streets meet. Packinghouses are found along the railroad tracks at the top, trees line Grand Boulevard, and citrus groves owned by the Tilsons are seen where Garretson Avenue meets Grand Boulevard at lower right. (Courtesy author.)

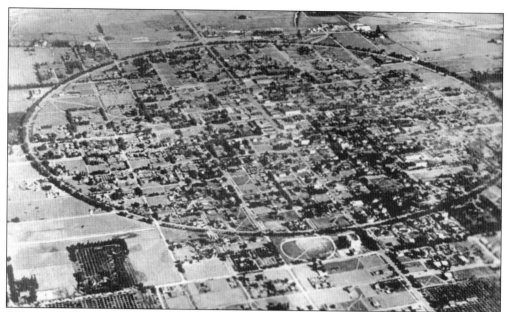

AERIAL VIEW FROM NORTHWEST TO EAST, C. 1935. The back of the postcard advertises the city as "CORONA—The Circle City. Corona's best known lemon district. A well balanced community. General farming, fruit growing and manufacturing: All on a worthwhile scale." Main and Sixth Streets bisect the circle here. Citrus groves thrived on Main Street until the late 1950s. (Courtesy Corona Public Library.)

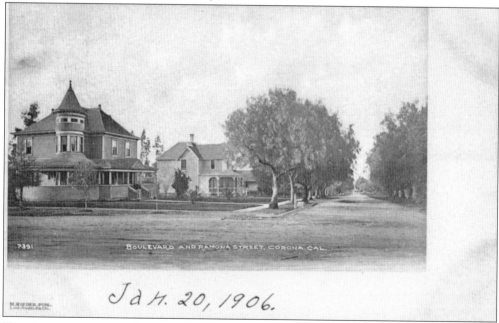

THE BOULEVARD AND RAMONA STREET, 1906. This turreted Queen Anne Victorian home at 1124 Ramona Street was built by Mason Terpening, a bank cashier who served on the Corona City Council from 1910 to 1924. Pepper trees line both sides of the street, and two churches are located north of this location—the First Methodist Church and the First Congregational Church. (Courtesy D. Williamson.)

22

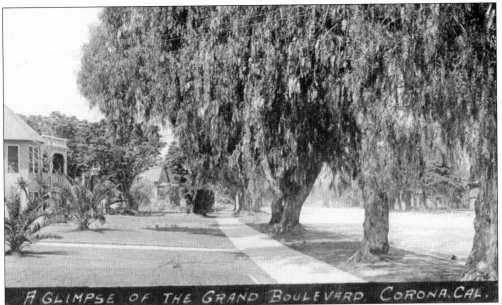

A GLIMPSE OF THE GRAND BOULEVARD CORONA CAL.

EAST GRAND LOOKING TOWARD MAIN STREET, EARLY 1900s. The first house on the left (1169 East Grand Boulevard) was built with a mixture of sand, gravel, and lime, resulting in thick adobe walls that were then covered with stucco. William Dyer built this home around 1888 for his daughter and son-in-law, Alma and Herb C. Foster. After restoration by Jerry and Jean Neumann between 2000 and 2003, it was awarded the 2003 Heritage Home Award by the Corona Historic Preservation Society. (Courtesy author.)

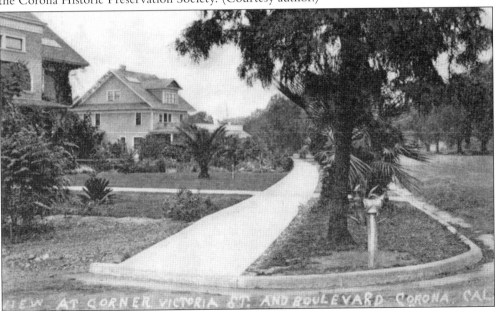

VIEW AT CORNER VICTORIA ST. AND BOULEVARD CORONA, CAL.

EAST GRAND BOULEVARD LOOKING EAST FROM VICTORIA AVENUE, EARLY 1900s. The Pentelow house (1136 East Grand Boulevard), the first home on the left, was built in 1905 by W. J. Pentelow, who once served as Corona's tree warden. Both the second (1122 East Grand Boulevard) and third houses (1114 East Grand Boulevard) on the left were built in 1904. Note the absence of curbs along Victoria Avenue. (Courtesy D. Williamson.)

23

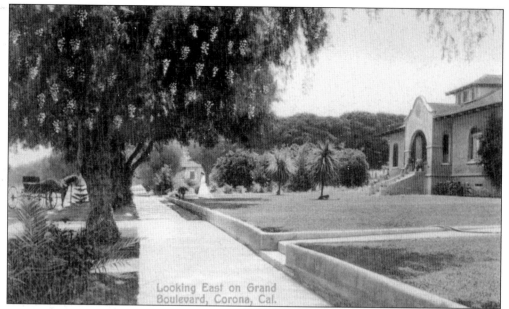

LOOKING EAST ON GRAND BOULEVARD TOWARD GARRETSON AVENUE, 1911. The Bonfoey house at 1209 East Grand Boulevard was built in 1905. The home has a different entry now, but some windows and the dormer remain the same. This postcard was made in Germany, hand painted by artists obviously unfamiliar with pepper berries since bunches of grapes were painted in the trees rather than berries. (Courtesy author.)

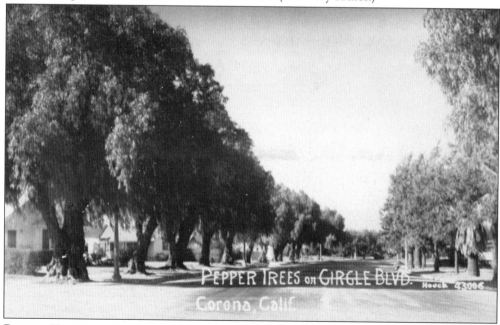

PEPPER TREES ON CIRCLE BOULEVARD, 1930s. This picturesque view of pepper trees and palms was taken from near Belle Street and is looking west along the 1100 block of West Grand Boulevard. The founders of South Riverside in 1886 envisioned horse races taking place along the circular boulevard. From early on, Coronans built lovely homes along the scenic route and paraded their fancy buggies around the boulevard. (Courtesy D. Talbert.)

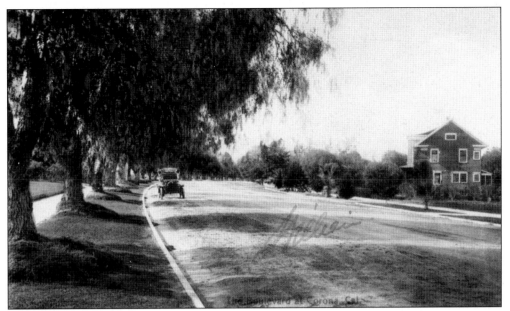

THE BOULEVARD LOOKING WEST FROM NEAR SOUTH MAIN STREET, C. 1910s. The three-story house on the right at one time stood at the southwest corner of Washburn Avenue and West Grand Boulevard. Ford dealer Warren Cropper once lived in this house, which has since been replaced by a medical clinic. Corona's first high school campus is not pictured but is located to the left of the trees in the foreground. (Courtesy D. Williamson.)

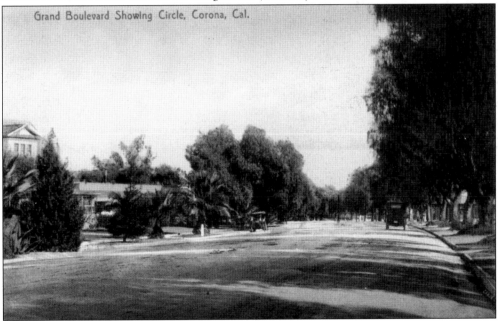

GRAND BOULEVARD SHOWING CIRCLE, C. 1910s. This postcard shows Grand Boulevard in the southeast quadrant of the circle. The multistory home on the left may very well be the W. H. Jameson home (1036 East Grand Boulevard), erected in 1893. Two open touring cars are pictured here along the 100-foot-wide roadway where world speed records were broken during the Corona Road Races. (Courtesy D. Talbert.)

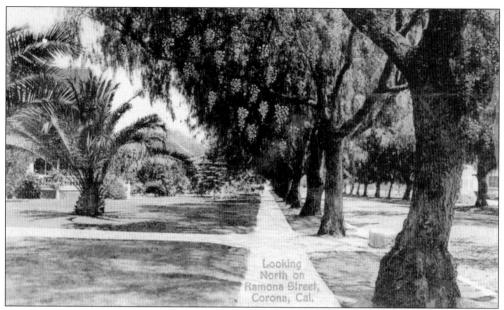

LOOKING NORTH ON RAMONA, 1911. Ramona, named for Helen Hunt Jackson's story *Ramona*, is an avenue, not a street as seen in this postcard, which was made in Germany, resulting in grape-like fruits suspended from pepper trees rather than pepper berries. The photograph was probably taken from South Grand Boulevard and Ramona Avenue looking north toward Sixth Street. (Courtesy author.)

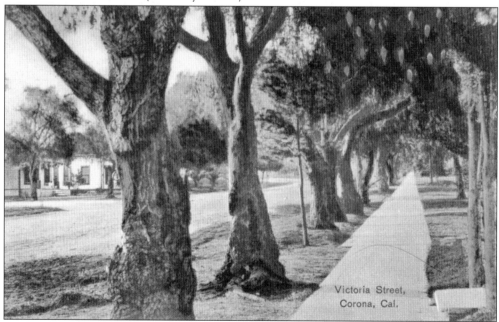

VICTORIA AVENUE LOOKING NORTH, 1930s. Victoria was misidentified as a street here. Named for England's Queen Victoria, this avenue is one of the widest within the circle. Because of its width, trucks from the groves in south Corona used to transport the freshly picked citrus fruit north to packinghouses along the railroad tracks just north of Grand Boulevard. (Courtesy D. Williamson.)

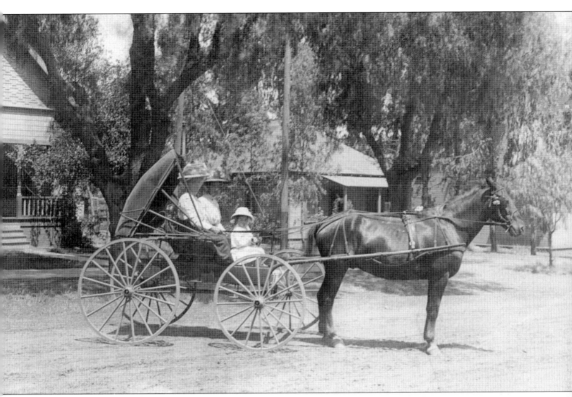

MEMBERS OF THE SERRANO FAMILY, C. 1904. Pictured here are Clarinda and Erlinda Serrano and their young cousin Aguenda Serrano on a horse and buggy, reportedly led by a horse named Prince, when there were few paved sidewalks and very dusty roadways. The Serrano family, who arrived in the Temescal Valley in 1818, was the first group of Spanish settlers to reside in Riverside County. Leandro Serrano established the Temescal Rancho, located roughly one mile north of Glen Ivy. Francisco Serrano, born in 1844, was the father of Clarinda and Erlinda and the son of Jose Antonio Serrano, brother of Temescal Rancho owner Leandro Serrano. Remnants of the Serrano tanning vats, used to make leather from cowhides, and old adobe structures survived along Old Temescal Road for over a century. (Courtesy Corona Public Library.)

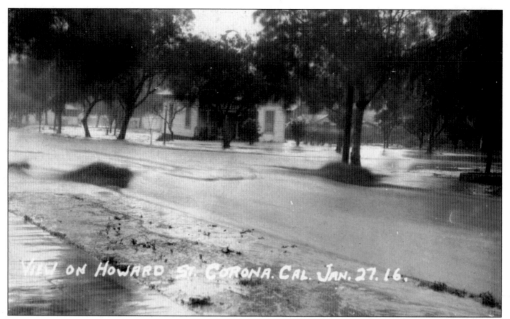

VIEW ON HOWARD STREET, JANUARY 27, 1916. This street was reportedly named after Howard Robinson, an early settler and father of the first baby born in South Riverside. Heavy rains caused the flood of 1916, and this postcard shows flooding at an intersection located inside the Grand Boulevard Circle. Note the turbulence at the corners where flows from different directions come together. (Courtesy Corona Public Library.)

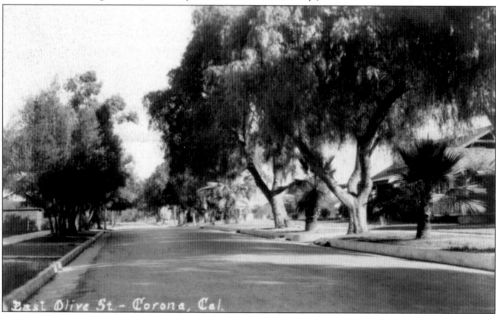

EAST OLIVE STREET, C. 1930S. This view looks toward Garretson Avenue. The house on the right (216 East Olive Street) was identified by its knee braces and exposed truss gable. The foliage has changed over the years, and pepper trees and palms have been replaced. Olive trees once graced this street according to newspaper reports from the 1916 flood, indicating many were washed away by the floodwaters. (Courtesy N. Benvenuti.)

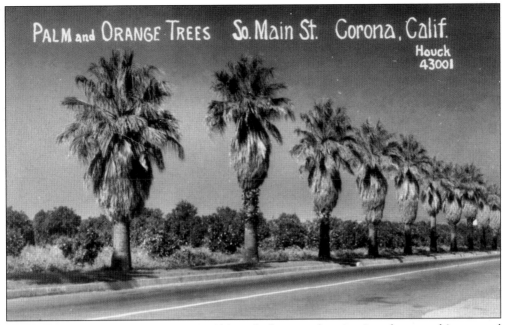

PALM AND ORANGE TREES, 1930s. Although the exact location is unknown, this postcard image is thought to have been taken on Main Street just south of Ontario Avenue looking northwest. The preservation of palm trees has been in effect at various times in Corona. When Chase Drive was realigned during development in south Corona, many tall palm trees were moved to northeast and northwest Grand Boulevard. (Courtesy D. Williamson.)

KELLOGG AVENUE, 1906. Although the street name is misspelled on the postcard, this roadway was named for H. Clay Kellogg, the civil engineer who laid out the city of South Riverside in 1886. Kellogg Avenue angles south from Garretson Avenue. Citrus groves once thrived in this area. (Courtesy author.)

29

CREPE MYRTLE, 1940s. In midsummer, Crepe Myrtle trees with brilliant magenta flowers once graced the roadways and coexisted with palm trees and citrus groves. The location is not identified but might have been Kellogg Avenue in south Corona. (Courtesy N. Benvenuti.)

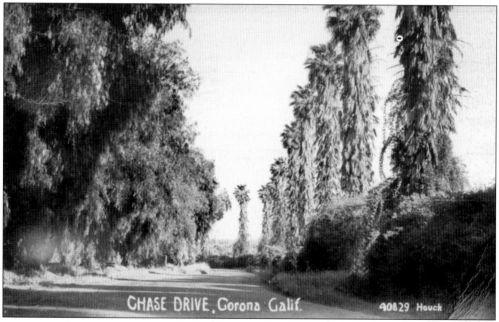

CHASE DRIVE, Corona Galif. 40829 Houck

CHASE DRIVE, 1930s. Cottages, built by the Foothill Lemon Company as housing for citrus workers, were once found along this roadway. The author of the postcard wrote, "This is a drive south of Corona among the orange groves. The tall bushes on the right by the palm trees are roses. Beyond them, is an orange grove. You can see the trees beyond the roses on the curve. This is all in the country and is a beautiful drive." (Courtesy author.)

Two

PUBLIC BUILDINGS AND PARKS

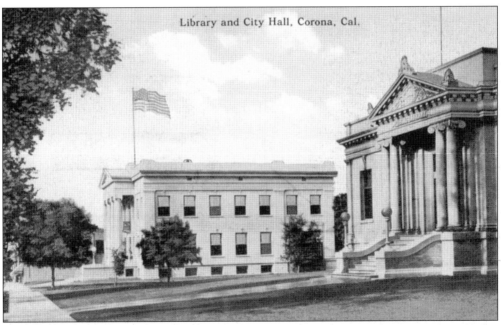

LIBRARY AND CITY HALL, 1914. This postcard clearly shows the juxtaposition of two structures forming Corona's earliest Civic Center. On the right is the Carnegie Library, built in 1906. It occupied the southeast corner of Eighth and Main Streets. Corona's first city hall opened in 1912 and was located across the street on the northeast corner. Both civic buildings are in the classical Revival architectural style. The library has a deeper setback from Main Street. (Courtesy author.)

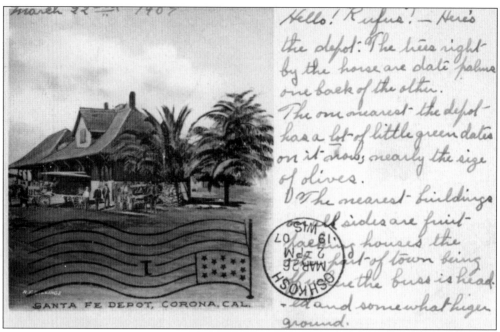

FIRST SANTA FE DEPOT, 1907. The handwritten message on the back reads, "Hello! 'Rufus!' Here's the depot. The trees right by the horse are date palms one back of the other. The one nearest the depot has a lot of little green dates on it now, nearly the size of olives. The nearest buildings on all sides are fruit packing houses the old part of town being off where the bus is headed and somewhat higer [sic] ground." (Courtesy D. Williamson.)

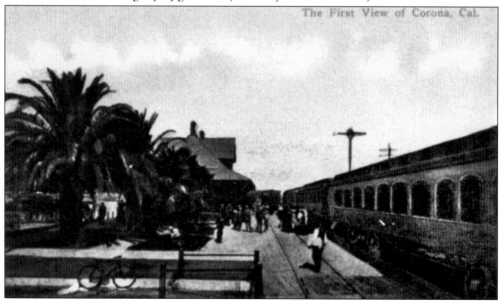

FIRST SANTA FE DEPOT, 1920s. Made of redwood, this Victorian-style depot played a huge role in the success of South Riverside, known as Corona 10 years later when the city's name changed. The first steam-driven train was due on June 27, 1887, and a spirited crowd gathered there anxiously awaiting its arrival. The train, however, arrived three days later to no fanfare whatsoever. (Courtesy S. Lech.)

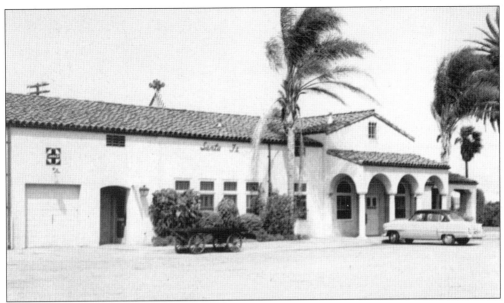

SOUTH SIDE OF CURRENT SANTA FE DEPOT, 1940S. This 191-foot-long depot was constructed in 1937 for $35,000. Typical of many similar stations on the Santa Fe line, it was built with stucco and a Spanish-style roof in the Mission Revival architectural style. The depot is located on the west side of Main Street between the railroad tracks and Grand Boulevard to the west of the Main Street overpass. Redwood from Corona's first depot was used in the construction of this one. (Courtesy N. Benvenuti.)

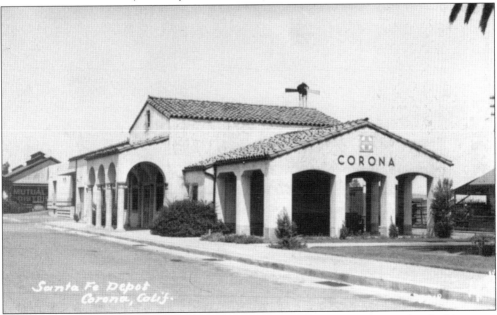

EAST END OF CURRENT SANTA FE DEPOT, 1940S. This photograph was taken looking west from Main Street. The Atcheson, Topeka and Santa Fe Railway Company erected the depot in recognition of the city's 50th Golden Jubilee celebration. In 2006, Corona purchased the depot. It is hoped this esteemed and historically significant site will continue to be recognized for the vital role it played in Corona's success. (Courtesy D. Talbert.)

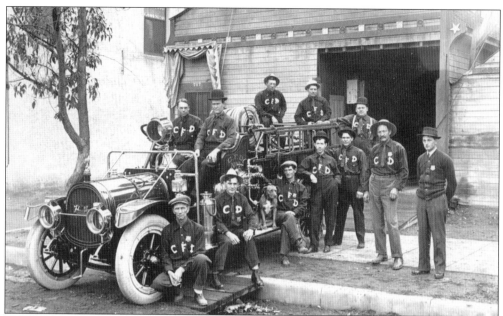

VOLUNTEER FIRE BRIGADE AND FIRST FIREHOUSE, 1913. The Corona Fire Department is pictured here with their new Pope-Hartford engine. The firehouse, built in 1898, was located in the 700 block of Main Street. Perle Glass, wearing the bowler hat and sitting at the steering wheel, was the fire chief. A historic marker was placed near the site by the Corona Historic Preservation Society on October 2, 1998. (Courtesy Corona Public Library.)

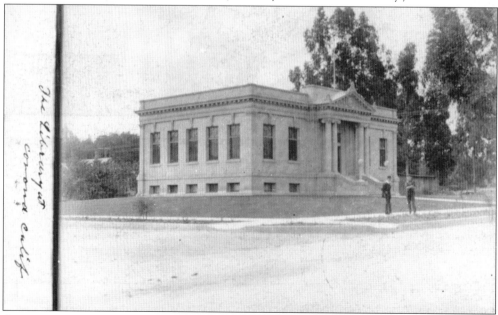

CARNEGIE LIBRARY, C. 1906. The grand opening of Corona's Carnegie Library was held on July 2, 1906, with much hoopla and celebration. It was built with an $11,500 grant from philanthropist Andrew Carnegie's foundation, which built 2,509 libraries worldwide. Sparse landscaping indicates this postcard photograph was taken shortly after construction was completed. (Courtesy N. Benvenuti.)

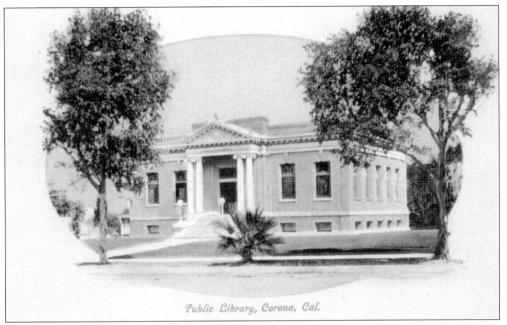

CARNEGIE LIBRARY, C. 1920. This hand-colored postcard, a stylized depiction with an encircling oval and trees in the foreground, was made in Germany. The library, designed by prominent architect F. P. Burnham and built by S. L. Bloom, served Corona for over 70 years. Many Coronans have wonderful memories of time once spent within the walls of this esteemed building. (Courtesy author.)

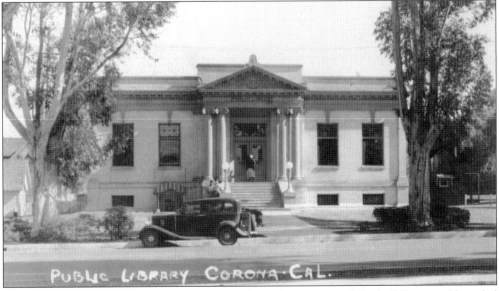

CARNEGIE LIBRARY, 1936. The library closed on July 3, 1971, and the building stood boarded up and vacant while the community was in an uproar about its fate. Striving to save the library, impassioned Coronans placed the library on the National Register of Historic Places in 1977. Nonetheless, this revered structure was razed in 1978 to make way for a Pioneer Chicken restaurant, which was never built. The site remains an empty weed lot after 28 years. (Courtesy D. Williamson.)

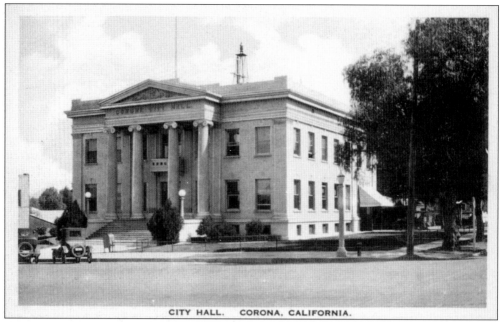

CITY HALL. CORONA, CALIFORNIA.

FIRST CITY HALL, C. 1915. Construction of Corona's first city hall was completed in March 1913 and served Corona for 49 years. The city council chambers were located on the north side of the upper floor, and the police and fire department offices were found in the basement along with the jail. In 1962, the city departments moved to the former campus of Corona's second high school at 815 West Sixth Street, and the original city hall building met the wrecking ball shortly thereafter. (Courtesy author.)

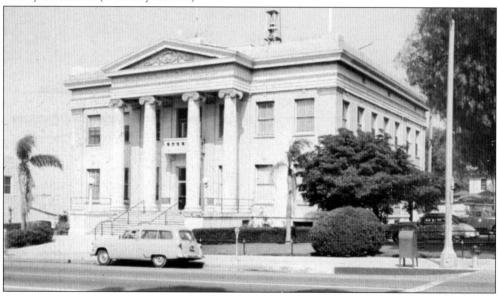

CITY HALL, C. 1957. A flagpole is seen in the right foreground and the air-raid siren structure projects above the roof. In 1951, the movie *Storm Warning* was filmed in downtown Corona starring Ronald Reagan, Ginger Rogers, and Doris Day. Many scenes featured city hall, which was depicted as a county courthouse. The First Baptist Church and the brick mortuary building, once nearby, are clearly recognizable in the movie. (Courtesy author.)

MASONIC TEMPLE AND SOUTHERN HOTEL, 1907. Both buildings were located in the 600 block on the west side of Main Street, and locals called the narrow alley between them "Pigeon Pass." Corona's opera house was located in the basement of Southern Hotel. In October 1892, 13 Corona men founded a Masonic Lodge. A charter was granted a year later. By 1902, the lodge had 60 members. These buildings were destroyed during urban renewal between 1969 and 1970. (Courtesy author.)

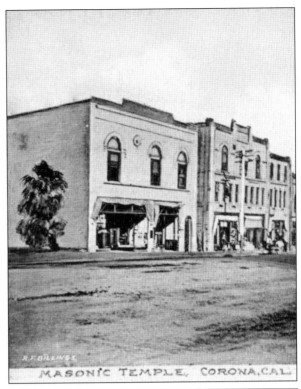

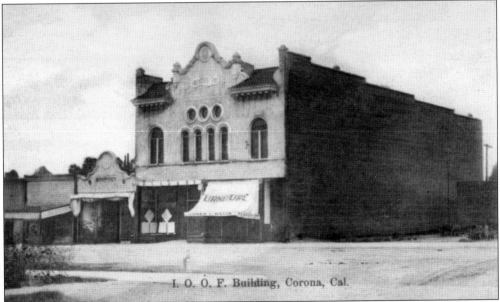

THE ODD FELLOWS BUILDING, C. 1910. The cornerstone for this structure was placed on May 30, 1902, during a community celebration. The lodge hall and its offices were located upstairs, and additional groups used the facilities for meetings and other purposes. Two storefront businesses occupied the downstairs; "James L. Davis Furniture" appears on the awning. Later Alpha Beta market was located on the lower floor. The structure was demolished around 1970. (Courtesy D. Williamson.)

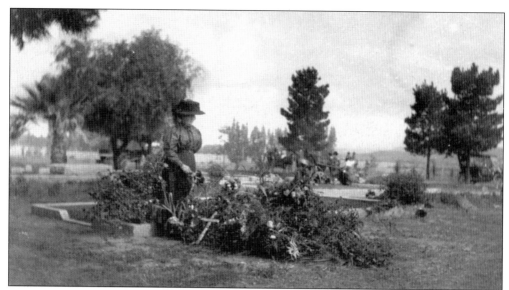

SUNNYSLOPE CEMETERY, 1911. Founded in 1892 as the South Riverside Cemetery, it is now known as Sunnyslope Cemetery and continues to be the only graveyard in Corona. The founders were important citizens of the fledgling community. Handwriting on the back indicates the woman on the postcard was placing magnolia blossoms on her husband's grave in honor of the Fourth of July. (Courtesy D. Talbert.)

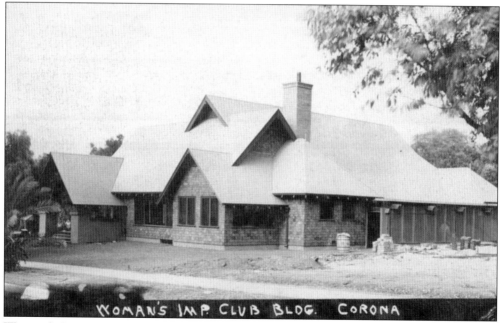

WOMAN'S IMPROVEMENT CLUB, 1913. The club was founded in 1899 by the Platt sisters and incorporated in 1910. Soon after, its motto was chosen: "The world is advancing; advance with it." The clubhouse, built for $7,183 on land donated by Ella Joy, opened in October 1913. For over 100 years, members have been credited with many community and social improvements. (Courtesy D. Williamson.)

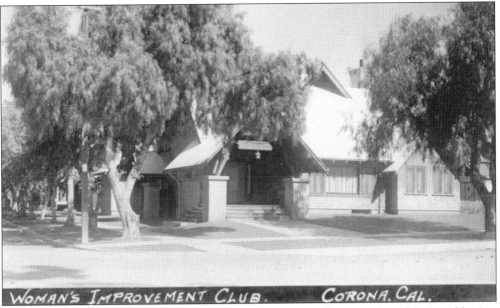

WOMAN'S IMPROVEMENT CLUB, C. 1940. Built in the Craftsman style and designed by Los Angeles architect Thomas Preston, who patterned it after a Welsh church, the clubhouse is still located at 1101 South Main Street. This imposing building was placed on the National Register of Historic Places on November 3, 1988. Membership of the Woman's Improvement Club in 2006 totals 140. (Courtesy N. Benvenuti.)

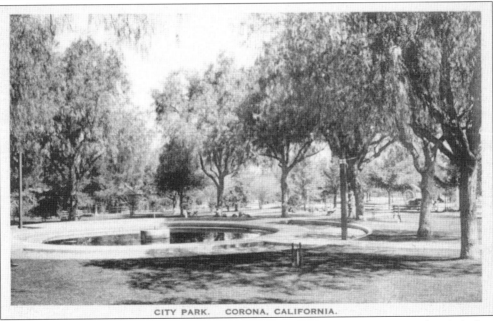

CITY PARK, 1920s. This once "unsightly lemon grove" was transformed into the city's first park in 1913 at a cost of $9,500. Amenities included wading pools, swings, a large slide, a teeter-totter, a baseball diamond, and a sandpile. On the right is a decommissioned cannon from an earlier war. It cost $120 and was removed and melted down during World War II for the war effort. (Courtesy D. Talbert.)

CITY PARK, 1967. When this photograph was taken, it had been more than 50 years since the park opened, and the wading pool was dry. Mature trees, well-maintained lawns, and roofed picnic areas continue to provide Coronans with a treasured resource for family and community events. The 1912 contract to establish the park included details such as hitching posts, tennis courts, and poultry-wire backstops for the baseball field. (Courtesy author.)

SPRINGTIME IN CITY PARK, C. 1955. Included in the original 1912 contract was a multipage list of landscaping materials, including 92 live oaks, pepper trees, sycamores, eucalyptus, bamboo, cactus, oleander, New Zealand flax, dracaenas, and roses. O. P. Bolin served as the caretaker of the park's trees in the 1950s and 1960s. Streetlights illuminated walkways during the evening hours. (Courtesy author.)

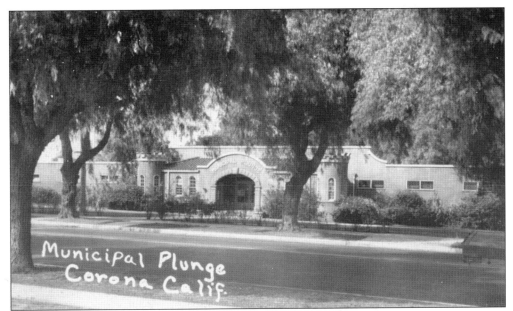

MUNICIPAL PLUNGE, C. 1938. Although the idea to establish a city plunge or swimming pool surfaced in 1915, it was not constructed until 1925 at the southwest corner of City Park facing East Sixth Street. The facility was designed by local architect Leo Kroonen Sr. and built by Corona contractor G. C. Berner for $15,000. The complex was demolished when the current pool at City Park was constructed in 1966. (Courtesy D. Williamson.)

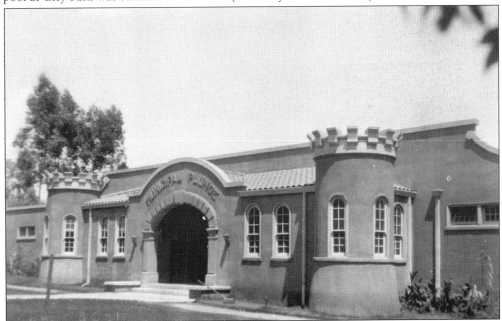

MUNICIPAL PLUNGE, 1931. The women's dressing room was on the left upon entering and the men's on the right. Mrs. Whitcomb once sat at a desk just inside the front door to collect fees from entering guests. Woolen swimsuits were available to rent there as well. The size of the plunge was 40 feet by 120 feet, and the water depth ranged from two to nine feet. (Courtesy Corona Public Library.)

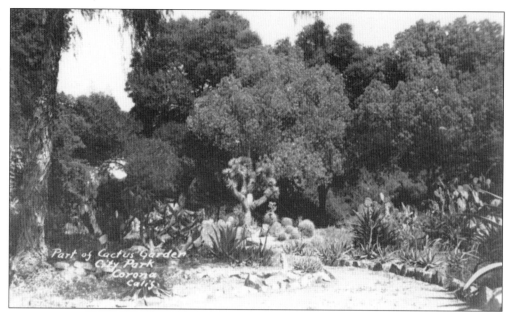

CACTUS GARDEN AT CITY PARK, 1930s. The location of this view is thought to be where the band shell is in 2006. It has been said that members from an early Corona Garden Society provided specimens from their own yards to establish this unique collection of cacti. (Courtesy author.)

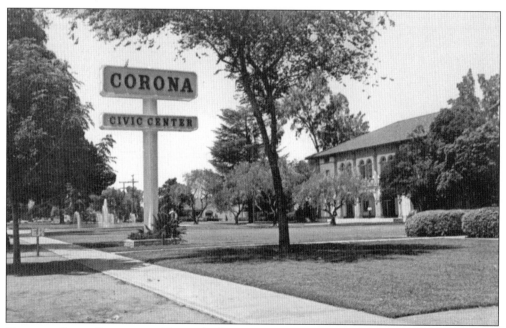

CORONA CIVIC CENTER, C. 1975. The former Corona High School campus at 815 West Sixth Street became a bustling Civic Center in 1962. In the late 1960s, donations were collected and the circular Pioneer Fountain was added. For over 40 years, both bridal parties and politicians have posed next to the fountain. The police department building joined the complex on the west end of the Civic Center in 1978. (Courtesy author.)

Three

COMMERCE

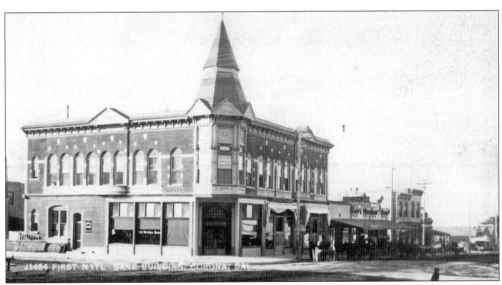

CITIZEN'S BANK, C. 1910. Founded on August 1, 1887, it originally occupied a 16- by 24-foot wooden building. Corona's first brick structure, this Victorian-style building completed in April 1888, remained for many decades at the northwest corner of Sixth and Main Streets. It underwent remodeling and "modernization" but met with demolition during urban renewal of the downtown in 1969. (Courtesy Corona Public Library.)

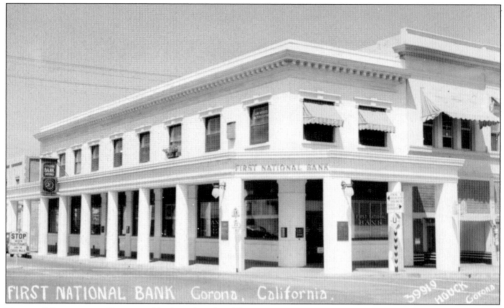

FIRST NATIONAL BANK, 1952. This building was painted white, and a shed roof portico was added to support the walls of the structure during "modernization" around 1939. The portico was removed sometime before 1950 due to the widening of Sixth Street. Citizen's Bank and First National Bank operated from the same building. Citizen's Bank handled the savings functions while First National provided safe deposits and vaults. (Courtesy author.)

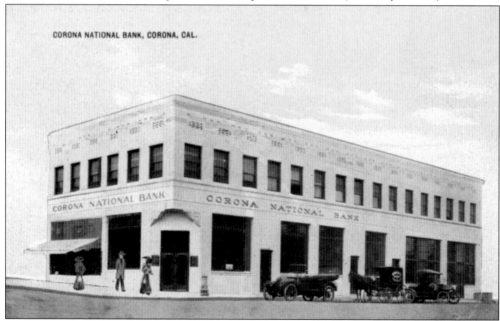

CORONA NATIONAL BANK, 1910s. This postcard shows a photograph of the bank with hand-drawn people. To the right of the door is a water fountain. The bank occupied the lower floor, while medical and dental offices were located above. The doctors' names are written on the windows. The building took on a new look when the bank was replaced by a drugstore, as seen on the next page. (Courtesy author.)

TEATRO CHAPULTEPEC, 1939. Proprietor J. Cruz operated this theater, which catered to Spanish-speaking members of the community. The interior was long and narrow, and watching a movie there was said to be like sitting inside a railroad boxcar, with seats running across the width of the car while the movie was pictured on one end. *Sir Lumberjack* is the film advertised on the sign. (Courtesy Corona Public Library.)

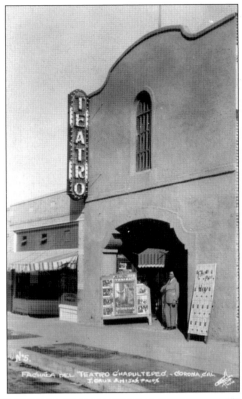

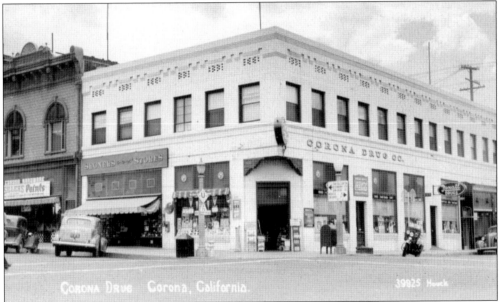

CORONA DRUGSTORE, 1953. Pictured here, from left to right, are Corona Hardware, Segner's 5–10–25¢ store, and Corona Drug Company. The door behind the motorcycle is where patients entered to access stairs to the dental and medical offices above. Posted on the streetlight is a no U-turn sign; a fire hydrant is nearby. A mailbox stands next to streetlight on the right upon which a distance sign is attached. (Courtesy D. Williamson.)

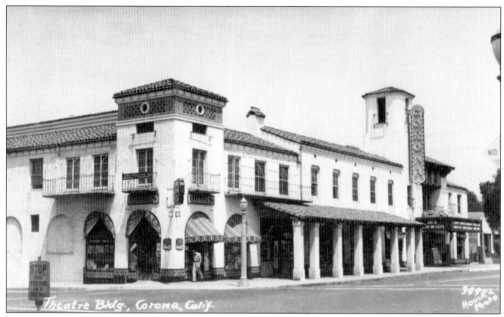

CORONA THEATER, 1939. Prominent architect Carl Boller designed this beautiful building, which still stands at 211 East Sixth Street. Stars attending opening night in 1929 included Laurel and Hardy, Charles Chaplin, Buddy Rogers, Buster Keaton, Mary Pickford, Tom Mix, Joan Crawford, and Norma Talmadge. Known as the Landmark Building for decades, in 2006, it is home to Amor Outreach Church. (Courtesy D. Williamson.)

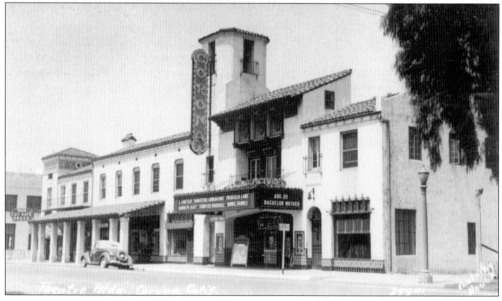

CORONA THEATER, C. 1939. Downtown was the heart of the city and the traditional gathering spot on Saturday evenings. Women shopped and men sat on car fenders and chatted while children went to the movies. In 1991, theater owners wished to demolish this building, however, local historic preservationists interceded, and their plans were thwarted. All movies on the marquee—*Daughters Courageous, Frontier Marshall,* and *Bachelor Mother*—were filmed in 1939. (Courtesy D. Williamson.)

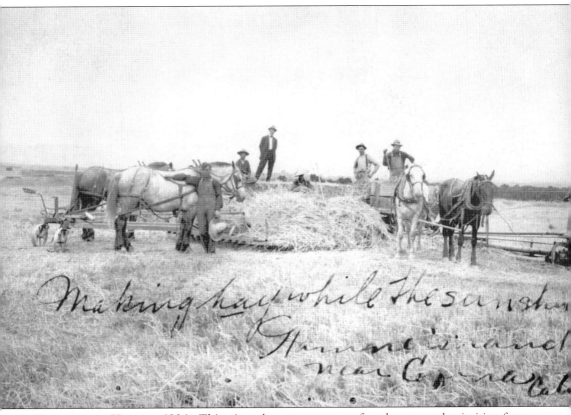

HARVESTING HAY, c. 1924. This view shows seven men, four horses, and primitive farm equipment in the process of harvesting hay. The men appear to be taking a break from loading hay onto the horse-drawn wagon on the right. Handwriting on the face of the postcard reads, "Making hay while the sun shines. Hamner's Ranch near Corona, Cal." Hamner's Ranch was once located east of Corona towards Arlington. (Courtesy S. Lech.)

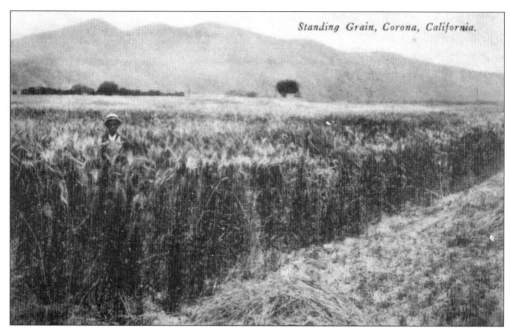

Standing Grain, Corona, California.

STANDING GRAIN, C. 1911. Shoulder-high grain stalks nearly engulf the man in this field. Power poles, a tree, and a nearby building are seen in the distance. The location is thought to be in the Home Garden area east of Corona. Printed on the back is "all grains do well around Corona, with irrigation a full crop is assured, without irrigation it is generally cut green for hay." (Courtesy author.)

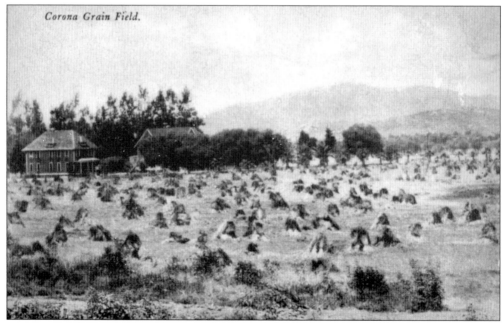

Corona Grain Field.

GRAIN FIELD, C. 1911. Piles of cut grain dot this recently harvested field. Two large buildings near the trees appear to be homes. Although the exact location is unknown, the photograph is thought to have been taken on the outskirts of town, east of Corona. (Courtesy J. Farr.)

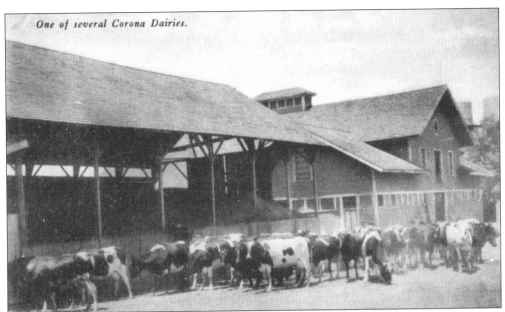

One of several Corona Dairies.

DAIRY, c. 1920. "From six to nine tons of alfalfa from the acre annually, with mild open winters, make dairying a very profitable business in this section. The close proximity to Los Angeles gives a never failing profitable market for all dairy products" is printed on the back of this postcard. A newspaper article from nearly a century ago estimated dairy cows in the Corona area to be around 2,000. (Courtesy N. Benvenuti.)

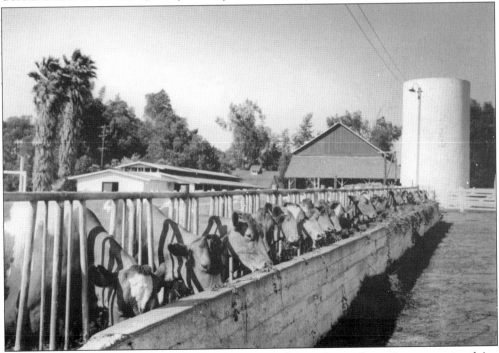

DAIRY COWS MUNCHING, 1952. This was a typical morning and evening scene at a dairy north of Corona off Hamner Avenue. The exact location is undetermined, but most local dairies were located in this area. (Courtesy Corona Public Library.)

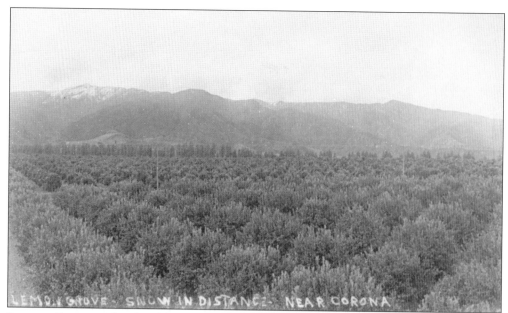

LEMON GROVE WITH SNOW IN DISTANCE, 1920S. The perfume of citrus blossoms once filled the air during springtime in Corona. One can understand why the scent was so pervasive when viewing this postcard of an expansive lemon grove in the southern portion of Corona. This postcard image probably was taken during the winter, though, as evidenced by snow atop the mountains. (Courtesy N. Benvenuti.)

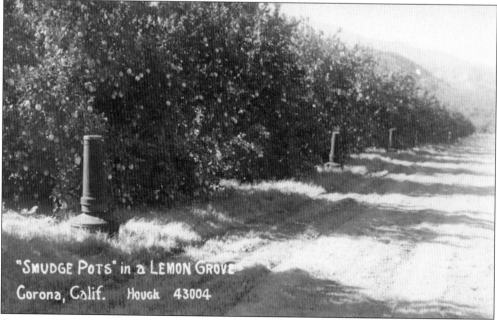

SMUDGE POTS IN LEMON GROVE, 1937. "Old style" smudge pots, with straight stacks, are seen in this postcard. Smudge pots gave off heat and protected fruit from the effects of freezing temperatures. The use of smudge pots caused a heavy, dark, smog-like condition throughout the area. Windows had to be closed to prevent the loathed and oily black soot from coming inside. (Courtesy D. Williamson.)

50

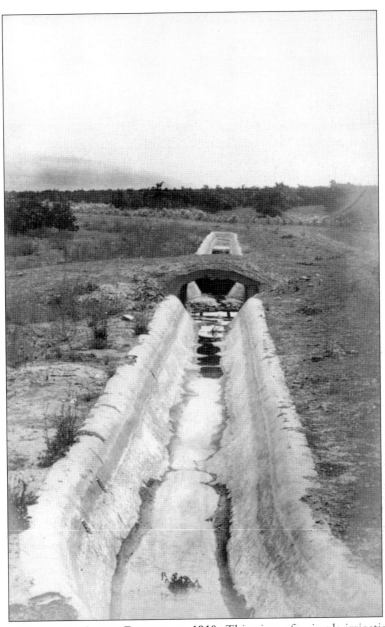

IRRIGATION DITCH AT CHASE RANCH, C. 1910. This view of a simple irrigation ditch on Chase Ranch symbolizes the importance water played in the success of early Corona and the technology used to transport it. As more and more property was developed, the need for water grew. Rudimentary irrigation ditches served as lifelines to bring water to thirsty groves and support the agrarian society of the early settlers of South Riverside. Without water, Corona would have remained a rocky, windswept desert. Corona earned its name as "the Lemon Capital of the World" primarily because it was able to overcome the challenge of bringing water into the area. At one time, Corona had 62 percent of all the lemon trees in Riverside County. It also had 16 percent of the orange trees in the county. The back of this postcard reads, "This is the place that we took a ride over the Ranch the day before you went. I wish it had of been today. E. La Tranch, Corona, Cal. Chase Ranch." (Courtesy D. Talbert.)

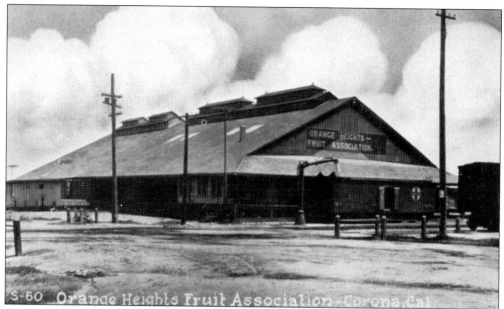

ORANGE HEIGHTS FRUIT ASSOCIATION, C. 1910. The Thieme Lemon Products plant was built in 1905 and located east of Main Street on the north side of the railroad tracks at Howard Street. By 1907, the packinghouse had changed its name to the Orange Heights Fruit Association. The packinghouse was greatly expanded in the early 1920s, and by the 1940s, it was renamed the Corona Foothill Lemon Company. (Courtesy D. Williamson.)

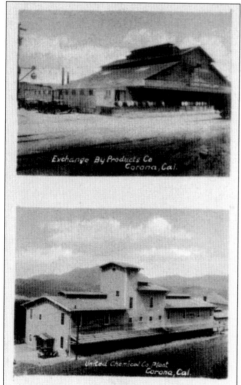

EXCHANGE BY-PRODUCTS COMPANY AND UNITED CHEMICAL COMPANY PLANT, 1910s. The largest citrus facility in Corona is pictured at left above. It was a cooperative business venture that used cull (waste lemons) to manufacture lemon oil and other products. The chemical plant below was located at the El Cerrito Ranch, owned by I. H. Flagler. Chemists there worked on projects utilizing lemons and pineapple juice. (Courtesy N. Benvenuti.)

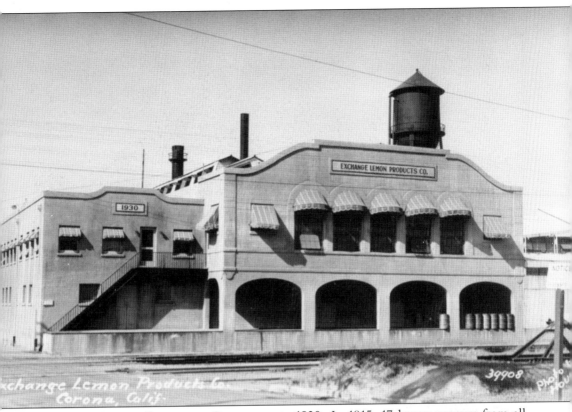

EXCHANGE LEMON PRODUCTS COMPANY, C. 1930. In 1915, 17 lemon growers from all over California met to form the Exchange By-Products Company, which operated in an old packinghouse. In 1921, the name was changed to Exchange Lemon Products Company. While the first product, lemon concrete, was unsuccessful, just a few years after the company's founding, the business was processing 10,000 tons of citrus annually. The second product, citric acid, was a basic product for many years. Lemon juice, lemon oil, and pectin were other profitable citrus products produced at this facility. The company became known as Sunkist Growers in 1948. Ten years later, in 1958, yearly production increased to 200,000 tons. Thirty-two buildings once occupied the site along Joy Street, and over the many years of operation, an average of 700 to 1,000 employees worked there at any given time. This building met the wrecking ball in late 2005. It is being replaced in 2006 with office and industrial buildings and is called Citrus Woods Business Center. (Courtesy D. Williamson.)

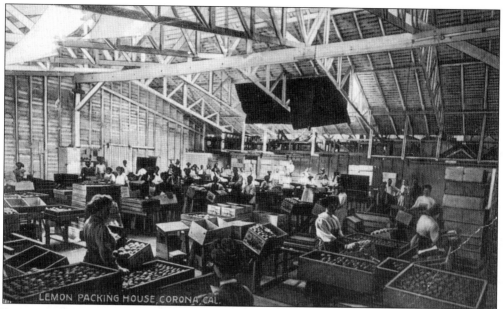

LEMON PACKINGHOUSE, C. 1910. Upon reaching a packinghouse, boxes of picked fruit were unloaded onto a platform, then brought inside where the fruit was sorted, graded, and packed. Women usually packed fruit into boxes; men did the lifting and other work requiring more brawn. Citrus labels identify this as the interior of a Corona Lemon Company packinghouse, which later became the Corona Foothill Lemon Company. (Courtesy Corona Public Library.)

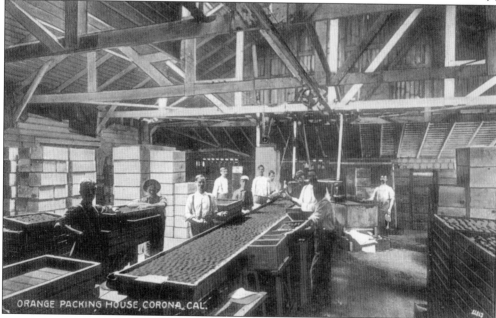

ORANGE PACKINGHOUSE, C. 1930. Floating oranges in water facilitated sorting, grading, and cleaning of the fruit. From this point, fruit was often waxed, stamped, and sometimes wrapped in tissue paper before being packed into wooden boxes for transport. In the 1930s and 1940s, citrus workers usually worked from 7:00 a.m. to 6:00 p.m. with only a lunch break. The pay was $9 for a six-day work week. (Courtesy Corona Public Library.)

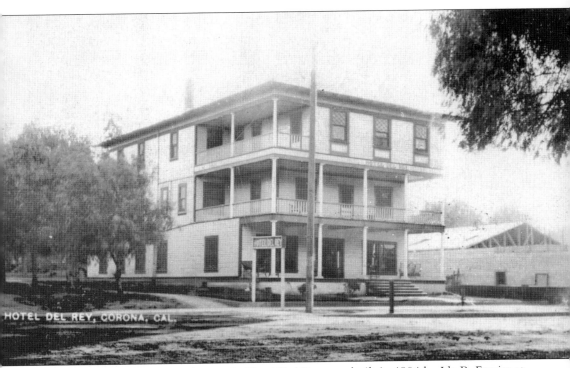

HOTEL DEL REY, CORONA, CAL.

HOTEL DEL REY, C. 1915. The stately Hotel Del Rey was built in 1904 by Ida B. Frazier at the southwest corner of Victoria Avenue and East Sixth Street. Because more interior space was needed a few years after its construction, the two-story hotel was hoisted up and a third level was added at ground level in 1907, which must have been quite an engineering feat at the time. The additional floor space provided enough area for a dining room, a large lobby, and a reception area. This impressive structure served the community as a site for banquets, meetings, parties, dances, and other special events. The Hotel Del Rey went through a host of different names throughout the years, including Hotel Hart, Centennial Inn, Colonial Inn, and finally, the Victoria Hotel. A historic marker was dedicated at this site by the Corona Historic Preservation Society on May 7, 1999. (Courtesy S. Lech.)

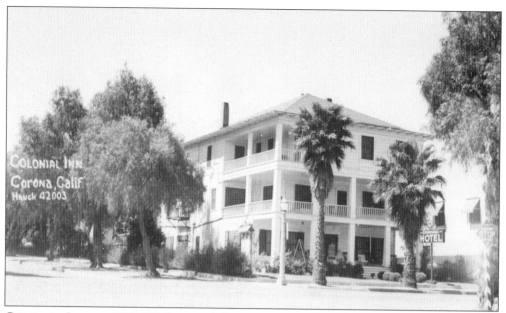

COLONIAL INN, C. 1947. While named the Victoria Hotel, it was threatened with demolition in 1998 to make way for a parking lot. The Corona Historic Preservation Society "rescued" it through collaborative efforts with the city of Corona and Bank of America. The structure was carefully disassembled and in 2006 is in storage bins at Corona Heritage Park, where it will be rebuilt and restored to serve Corona once again as a community events center. (Courtesy J. Farr.)

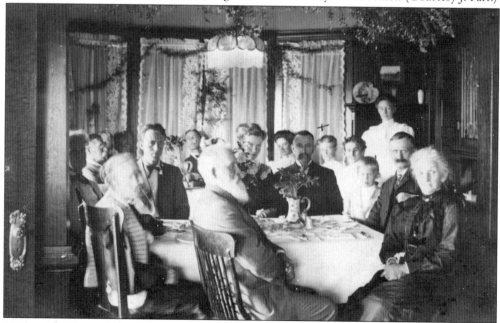

A DINING EXPERIENCE, C. 1918. Seventeen diners pose in what is thought to be the dining room of the Hotel Del Rey. They are enjoying themselves here as they await their meals. Details in the room include lace-paneled curtains, eucalyptus branches hanging from the ceiling, a fringed electric lamp, and china pitchers with plants for centerpieces. The dining area was located at the rear of the hotel on the lower floor. (Courtesy R. Harris.)

HOTEL KINNEY, C. 1927. This postcard shows the hotel and the Kinney Café in the upper frame and the ladies' parlor, located on the second story, in the lower frame. It looked to be a very accommodating area for relaxing and sharing conversation. Downstairs was the reception desk and men's lobby, with spittoons and other appropriate furnishings. Nicholas and Amanda Norton ran the hotel from the 1930s to around 1945. (Courtesy author.)

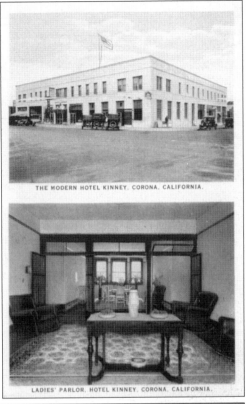

THE MODERN HOTEL KINNEY. CORONA. CALIFORNIA.

LADIES' PARLOR, HOTEL KINNEY, CORONA, CALIFORNIA.

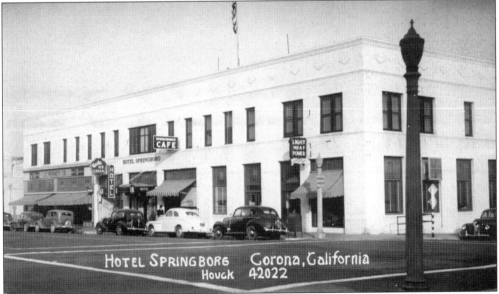

HOTEL SPRINGBORG Corona, California
HOUCK 42022

HOTEL SPRINGBORG, LATE 1940S. Axel Springborg purchased Hotel Kinney after World War II. Businesses, from left to right, were the JCPenney Company, Mava Ice Cream, the entryway to the hotel, Springborg Café, and the Power, Heat and Light Company. Hotel rooms were on the upper floor. A mailbox is on the corner along with a streetlight with a sign affixed indicating a traffic signal lies ahead at Sixth and Main Streets. (Courtesy author.)

HARTY'S MOTEL, 1950s. On the back of the postcard is found the following identifying information: "HARTY'S MOTEL (Highways 91-18-71) 953 W. 6th St. Corona, California. Phone: Redwood 7-9103 (today this would be 737-9103), 10 units—4 kitchens—restaurants near. Individually cooled by refrigeration. Tiled showers. Wall to wall carpeting. FREE T-V, Mr. & Mrs. James Gallery, Owners-Managers." In 2006, it is a Motel 6. (Courtesy author.)

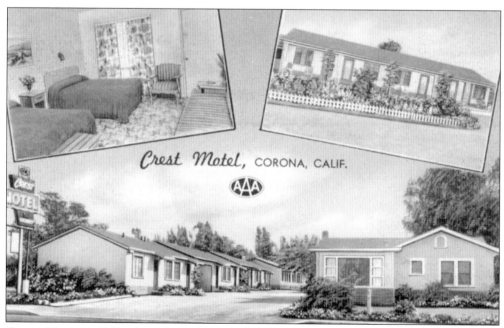

CREST MOTEL, 1960s. Location information on the back of the postcard reads, "Crest Motel 1432 W. Sixth St., On Hwy. 18, 71, 91 Corona, Calif. Phone 1524-R. Owner-Managed." In 2006, the Crest Motel is still in existence on the west side of town. (Courtesy author.)

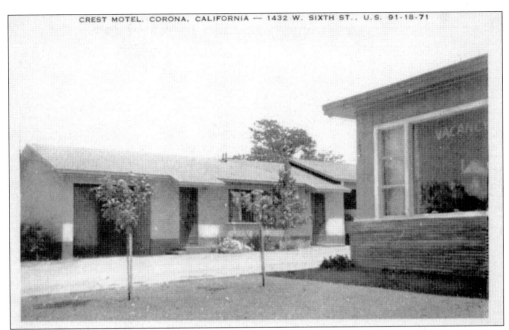

CREST MOTEL, 1960S. A description of the motel is written on the back of this postcard and states, "An attractive well managed motel with private garages, Tub—Tile showers, thermostatic heat, kitchens complete. Singles, doubles, family units. Convenient to Corona Naval Hospital. Shuffleboard, horseshoes, and climate ideal for sunbathing summer and winter." (Courtesy D. Talbert.)

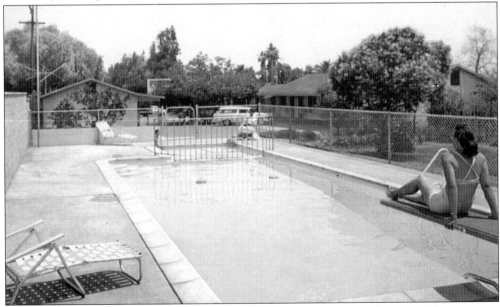

CREST MOTEL, EARLY 1960S. The swimming pool was located at the rear of the property. Promotional wording on the back of this card indicates the motel was located "60 minutes from Los Angeles and less to Ocean and Mt. resorts. Good restaurants nearby." Corona was a popular stopping point before the advent of the freeway, being at about the halfway point between Los Angeles and desert resort communities. (Courtesy author.)

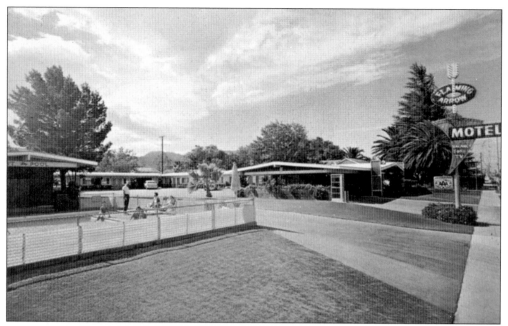

FLAMING ARROW MOTEL, C. 1965. This motel still stands at 1030 West Sixth Street. Printed on the back was the following: "Corona's finest motel located just a few minutes from Disneyland and Knott's Berry Farm. Heated pool. Cooled by refrigeration; thermostat heat; free T.V." In 2006, the street has been widened, the pool has been filled in, and the fletched arrow sign pole has been replaced. (Courtesy author.)

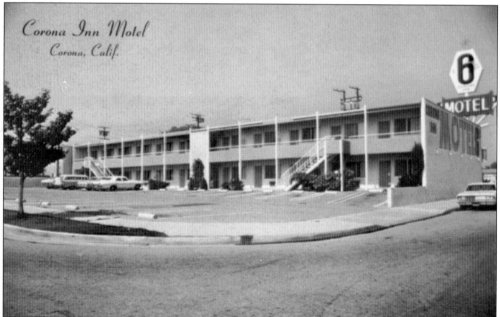

CORONA INN MOTEL, EAST SIDE, C. 1960. This motel is still located at 180 East Third Street on the southeast corner of Third Street and Ramona Avenue and is easily reached from Main Street exits off the Riverside Freeway. Advertising on the back reads, "Air conditioned—Free television—Room telephones—Most credit cards accepted. 42 units." (Courtesy author.)

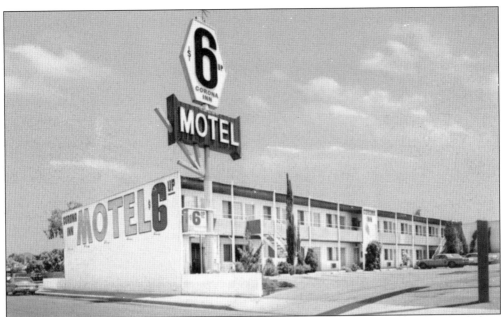

CORONA INN MOTEL, WEST SIDE, C. 1960. According to the signage in this postcard, rooms are available starting at $6. This overnight resting spot for travelers was originally built as a Travelodge. Over the years, it has experienced numerous name changes. In 2006, it is surrounded by a wrought-iron fence and is called Budget Inn and Suites. (Courtesy author.)

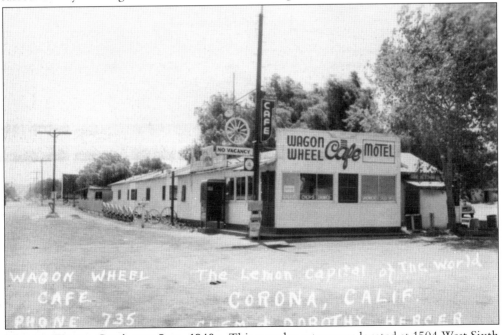

WAGON WHEEL CAFÉ AND INN, 1940s. This popular eatery was located at 1504 West Sixth Street on the southwest corner of Sixth and Yorba Streets (before the realignment of Tenth and Smith Streets). Signs in the windows advertise steaks, chops, drinks, sandwiches, and Silex coffee. Many Coronans recall the friendly service and tasty food once provided at the café. Lodging was provided in a few of the rooms. (Courtesy author.)

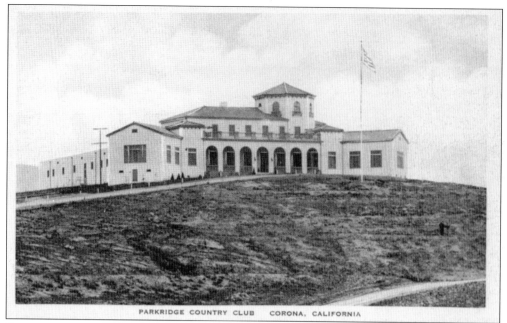

PARKRIDGE COUNTRY CLUB CORONA, CALIFORNIA

PARKRIDGE COUNTRY CLUB, C. 1927. Silent film actress Clara Bow became the first member of Parkridge Country Club, built in 1926, when she won a dance contest held at Café Montmartre in Hollywood; the first prize was a membership to the club. Actors Henry Fonda and Burt Lancaster enjoyed weekend getaways here. The club fell on hard times, closed down, reopened as Sierra Vista Sanitarium, and was eventually demolished. Cresta Verde Golf Course is found here in 2006. (Courtesy author.)

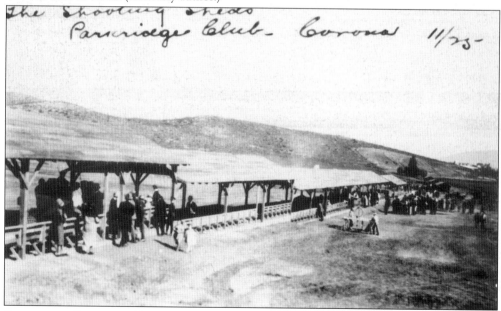

PARKRIDGE SHOOTING RANGE, C. 1927. Founded in 1925, Corona's earliest rifle and pistol shooting venue was located in the flat below Parkridge Country Club, which was built a year later in 1926. The club can be seen in the distance on the right. Subterranean tunnels provided a safe pathway for staff and others to walk to and from the targets. (Courtesy Corona Public Library.)

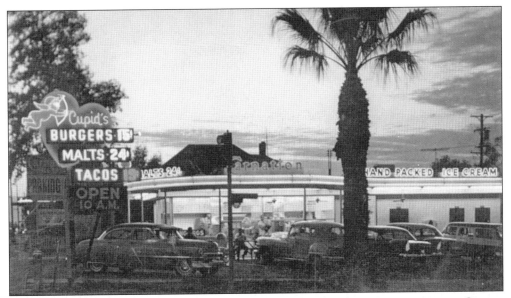

CUPID'S, LATE 1950S. A neon sign identifies this popular drive-in restaurant, a Corona landmark for approximately 50 years and a popular hangout for teenagers. In this postcard, prices are "Burgers 15¢, Malts 24¢." Tacos are mentioned on the exterior sign, and hand-packed ice cream is offered on the menu inside. Ceiling fans created cooling airflow to indoor customers, and waitresses on roller skates once provided carhop service to patrons. In 2006, the site is a Mexican restaurant. (Courtesy author.)

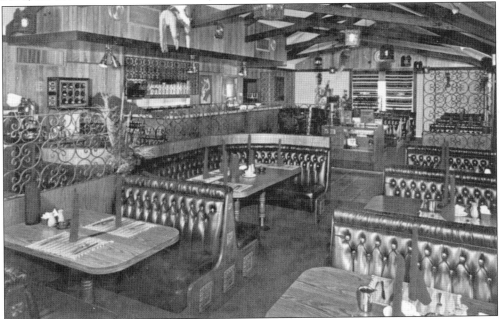

INTERIOR OF COMIDA LINDA RESTAURANT, C. 1967. Located at 1703 West Sixth Street, this Mexican restaurant offered comfortable seating (note the diamond-tufted cushions in the booths) and "Mexican Food with a flair to satisfy the discriminate diner," as is printed on the reverse side of this postcard. The hanging piñata and serapes along a wall add atmosphere to the dining area. A car dealership is located on this site today. (Courtesy author.)

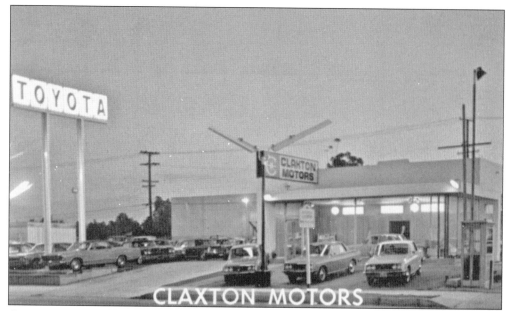

CLAXTON MOTORS, EARLY 1970S. Corona's first Toyota dealership was located at 808 East Sixth Street where Bell's Truck and Auto Sales is now found. This dealership is to the west of the current Corona Chamber of Commerce office. A "historic landmark ahead" sign along the curb refers to Corona City Park, which is located one block to the east on the north side of Sixth Street. (Courtesy, D. Talbert.)

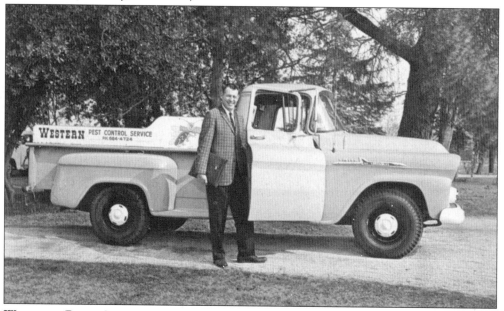

WESTERN PEST CONTROL SERVICE, LATE 1950S. Pictured here is Warren L. Wallace, manager of the Riverside–Corona area. Western Pest Control Service was "established in 1932, following the Long Beach earthquake, when it was discovered that most buildings that were destroyed had been structurally weakened by severe termite and/or fungus damage" and offered the following services: "Fumigation, termite control, general pest control, estimates and prompt escrow papers." (Courtesy author.)

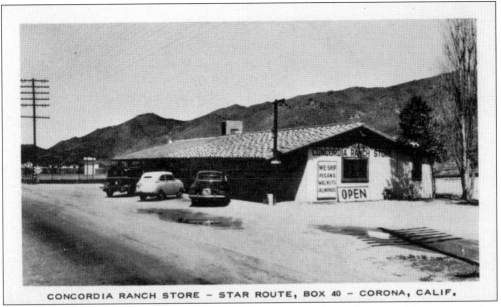

CONCORDIA RANCH STORE – STAR ROUTE, BOX 40 – CORONA, CALIF.

CONCORDIA RANCH STORE, C. 1958. This store sold snacks to thirsty and hungry travelers along the Star Route and was once located on the east side of Temescal Canyon Road near the entrance to the Glen Ivy Hot Springs, which was on the west side. A sign on the building reads, "We ship pecans, walnuts, almonds." The car on the right is a Studebaker. (Courtesy author.)

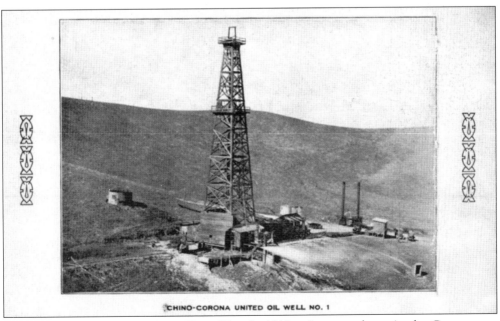

CHINO-CORONA UNITED OIL WELL NO. 1

CHINO-CORONA UNITED OIL WELL NO. 1, 1910s. Any petroleum in the Corona area was near the Chino fault line, which runs generally from the intersection of the 91 and 71 freeways north to the 60 freeway. This oil well was established on the Newman property, located northwest of Corona in the vicinity of the 71 Freeway (Corona Expressway) in the Butterfield area of Chino Hills. (Courtesy author.)

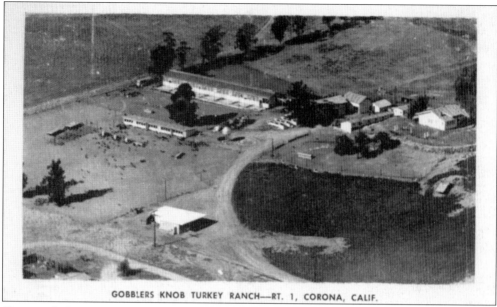

GOBBLERS KNOB TURKEY RANCH—RT. 1, CORONA, CALIF.

GOBBLER'S NOB TURKEY RANCH, 1950s. This turkey-raising business was located on a hill (or nob) off Hamner Avenue near the present-day Norco campus of Riverside Community College. At the time this postcard was printed, the address of the ranch was Corona. Fresh turkeys were available for purchase from the white building in the foreground. (Courtesy S. Lech.)

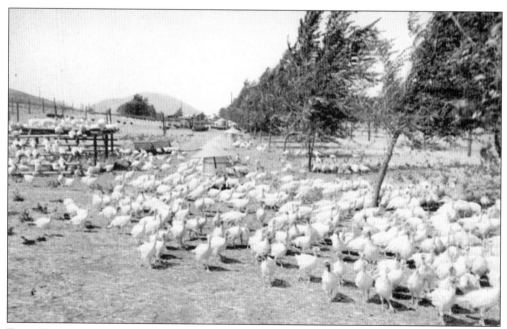

FINE FEATHERED FRIENDS, 1950s. This postcard is thought to have been taken looking north at the appropriately named Gobbler's Nob Turkey Ranch. Although Hamner Avenue cannot be seen, it is off to the right. Beacon Hill is in the distance. On the back is printed, "One of the very few flocks of broad-breasted white turkeys in the west." (Courtesy author.)

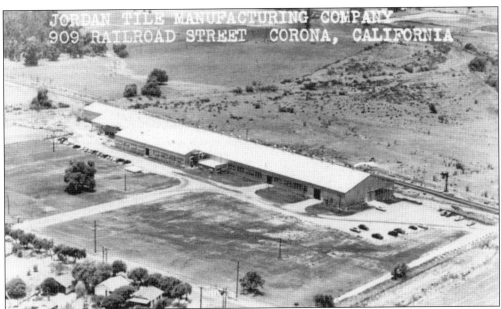

JORDAN TILE MANUFACTURING COMPANY, 1950s. The wording on the back of this postcard reads, "You are cordially invited to visit our new plant in Corona, California which is now producing a complete line of Mosaic Harmonitone floor tile of the unglazed porcelain type. We are now able to give prompt service on your ceramic orders." The company was located at 909 Railroad Street, which runs diagonally in the lower left. The U.S. Tile Company operates there today. (Courtesy author.)

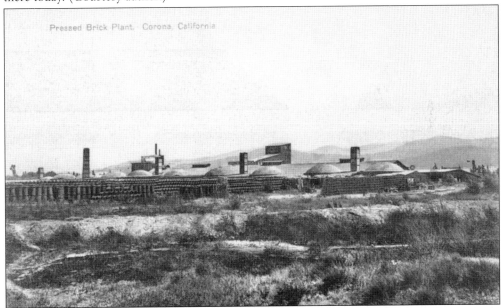

PRESSED BRICK PLANT, 1930s. According to a *Corona Courier* article, clay beds were discovered in Temescal in March 1905 and the hopes of the community were for "the manufacture of potters' ware, such as porcelain and dishes for table use." This plant was located near the southwest corner of Cajalco and Temescal Canyon Roads. The Crossings at Corona, a retail, dining, and entertainment center, is found north of this area. (Courtesy D. Williamson.)

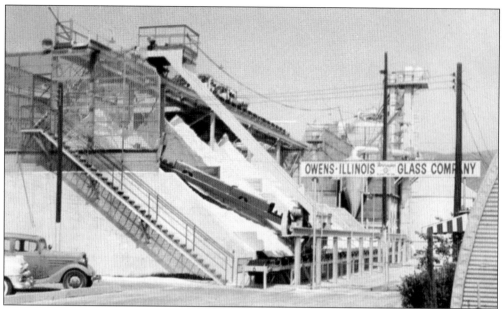

OWENS-ILLINOIS GLASS COMPANY, C. 1950. This silica-extraction business was found in the Temescal Valley where the Dos Lagos community is now being developed along the I-15 freeway. As sand was removed, deep pits resulted approximately where the lakes have recently been created. After extraction, sand was sent to the main plant seen in this postcard. The fine sand granules were separated and sent to glassmakers throughout the nation. (Courtesy author.)

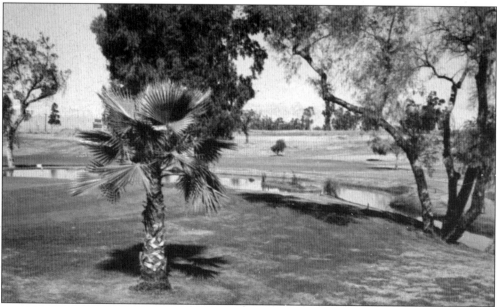

MOUNTAIN VIEW GOLF COURSE, C. 1985. Mountain View Golf Course opened in 1962 and was known as Serfas Club Golf Course for a time. Printed wording on the back reads, "Snow capped mountain range seen from the Mountain View Golf Course." This view looks toward Mount Baldy. This regulation golf course features narrow, tree-lined fairways, and houses now surround the course. (Courtesy author.)

Four

CHURCHES AND SCHOOLS

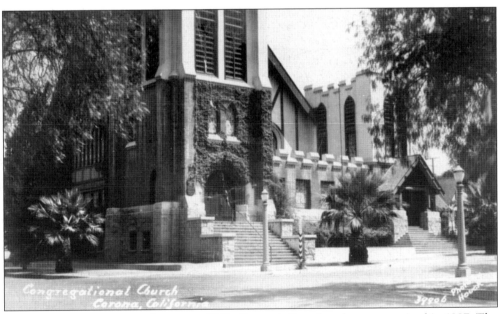

FIRST CONGREGATIONAL CHURCH, 1939. Corona's first church was organized in 1887. The original wooden church was built at 809 Ramona Avenue for $2,200 and was moved in 1948 to a site on East Sixth Street. This Tudor Revival building, designed by noted California architect Norman Foote Marsch and made of granite from a local quarry, was built for $35,000. It was dedicated on October 5, 1911, and continues to serve its congregation. (Courtesy D. Talbert.)

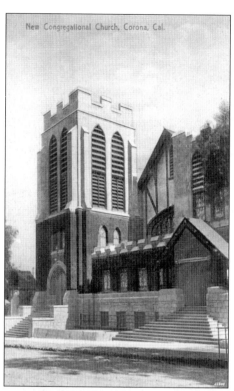

FIRST CONGREGATIONAL CHURCH, 1939.
The sanctuary's interior includes a suspended balcony, original wooden pews, and beautiful stained-glass windows. The resounding tones of the Robert Morgan pipe organ and the exceptional acoustics of the sanctuary enrich the quality of the spoken word. The Corona Historic Preservation Society dedicated a historic marker here in July 1996 as part of the city's centennial celebration of Corona's incorporation. (Courtesy D. Williamson.)

FIRST BAPTIST CHURCH, 1958. N. C. Hudson's home (1052 East Grand Boulevard) is where the church was first organized. The church building remained in use at 155 West Eighth Street until it burned down in January 1937. The present Colonial Revival–style sanctuary, erected in 1937–1938, was built by the Pinkerton-Jameson Company. A historic marker was dedicated here on January 27, 2005, by the Corona Historic Preservation Society. (Courtesy author.)

CHRISTIAN SCIENCE CHURCH, C. 1920. A church was located in this once residential property at 1021 South Main Street. Most recently, it has been home to a chiropractor's office (in the front portion of the structure) and Main Street Café at the rear. (Courtesy author.)

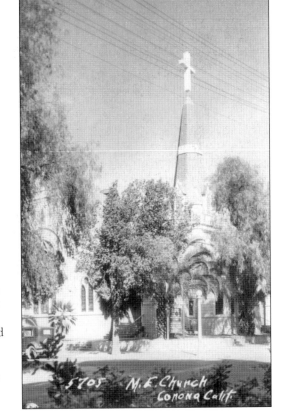

METHODIST EPISCOPAL CHURCH, C. 1908. The congregation first organized in 1887, and this steepled sanctuary was built and later dedicated on April 7, 1889. In 1905, the church was valued at $2,500, and membership had reached 169. This quaint church served an expanding congregation for 49 years and was dismantled in 1938 to make way for a new sanctuary. (Courtesy D. Talbert.)

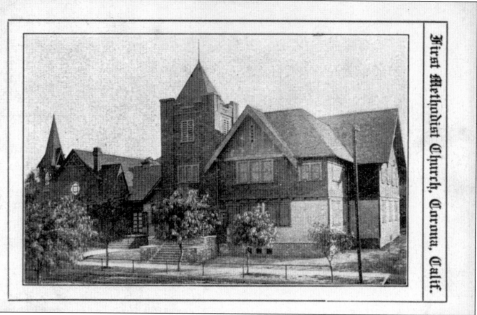

FIRST METHODIST CHURCH, C. 1940. This postcard image, taken from the west side of Main Street, north of Tenth Street, shows the new sanctuary, at right, which replaced the original one. The fellowship hall is on the left. The church is still located on the southeast corner of Main and Tenth Streets. (Courtesy author.)

FIRST METHODIST CHURCH, 1946. This view, taken from Tenth Street and Ramona Avenue, shows the fellowship hall on the left and the sanctuary on the right. Located at 1140 East Tenth Street, the church complex was sold to the Spanish Seventh-Day Adventist Church in 2005. Because the new Methodist church has not yet been built, the Adventist church allows the congregation to continue meeting in their facility. (Courtesy author.)

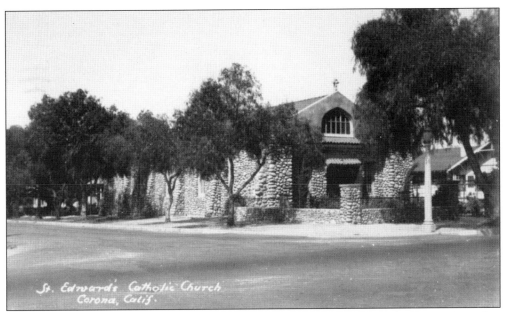

ST. EDWARD CHURCH, C. 1945. This unique Gothic Revival–style church was dedicated in July 1919 and occupied the northeast corner of Merrill and Sixth Streets until 1951. In order for it to be built, members of the congregation gathered fieldstones over a period of three years. After its demolition, this corner was home to Cropper Ford, then Hemborg Ford, and is now an auto repair business. (Courtesy author.)

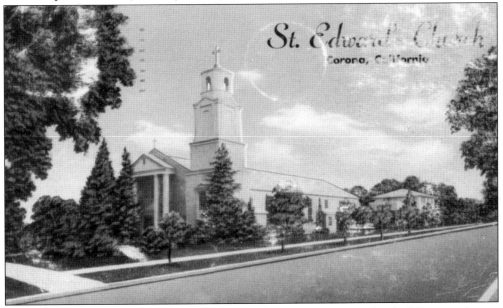

ST. EDWARD CATHOLIC CHURCH, C. 1958. Dedicated in 1951, this building stands as a beacon to parishioners and the community on West Grand Boulevard. It was named for Edward Alf after his widow made a substantial donation toward the building of the church. Many proud traditions have continued here throughout the decades. St. Edward Catholic School is located nearby and currently educates students from preschool through eighth grade. (Courtesy J. Farr.)

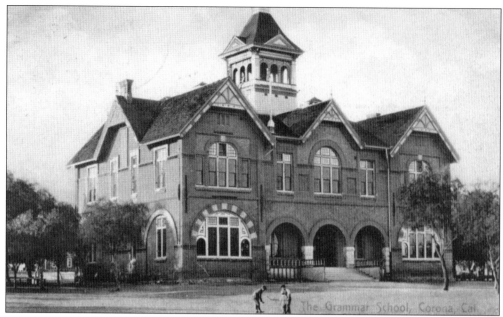

THE GRAMMAR SCHOOL, C. 1910. This impressive building was constructed of brick and stone in 1889 for $20,000. Measuring 100 feet by 60 feet, it was located on Tenth Street between Victoria and Howard Streets. All grades attended classes here until the first high school on Main Street opened in 1907. The school bell could be heard throughout town, beckoning students in the morning and releasing them to go home in the afternoon. (Courtesy D. Williamson.)

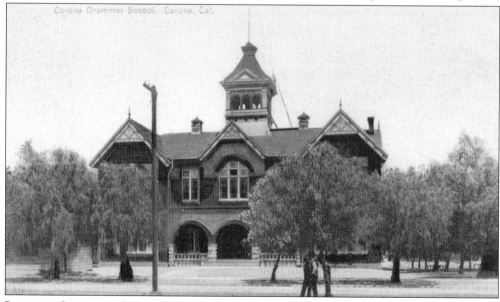

LINCOLN SCHOOL, 1910s. Although named the Lincoln School, it continued to be known as Corona School because it was the only school in town until Washington Grammar School was built on East Grand Boulevard in 1911. Due to safety concerns in 1913, the second story and bell tower were removed. The remaining lower floor housed the kindergarten, cafeteria, and auditorium. In 1914, another building was added to the campus to provide additional classrooms. (Courtesy author.)

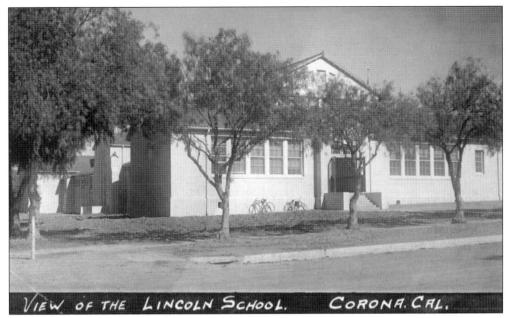

LINCOLN SCHOOL, 1920S. This U-shaped building, with a two-story section in the center, was added to the campus in 1914. Classrooms for grades one through four were on the lower level, and the fifth- and sixth-grade classes met on the second floor. Eventually the entire campus was deemed unsafe and another Lincoln School was built at 1041 Fullerton Avenue. Students and staff moved there in 1950. (Courtesy D. Williamson.)

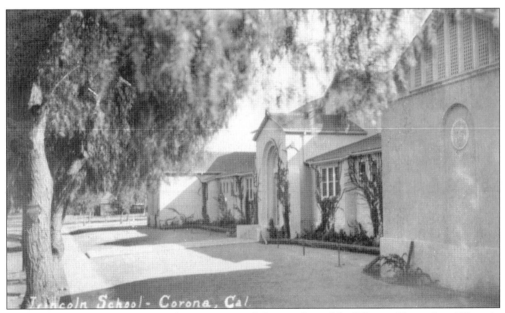

LINCOLN SCHOOL, C. 1940. The east wing of this U-shaped building still stands at Victoria Park. The complex served as the Corona Unified School District administration facility until 1968 when it moved to the Buena Vista site after it was vacated by Kimbell School elementary students. A historic marker placed by the Corona Historic Preservation Society was dedicated at this site on November 7, 1998. (Courtesy D. Talbert.)

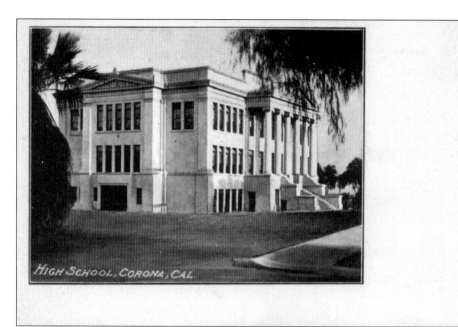

FIRST CORONA HIGH SCHOOL, 1907. This imposing edifice, designed in the classical Revival style by architect F. P. Burnham, was built in the 1200 block of Main Street. It totaled more than 8,000 square feet with an intended capacity of 180 students. An athletic field was added to the campus for $9,000 in 1913. During the 1930s, tennis courts were located in the area to the left of the building. The blank space was provided for a written message (Courtesy D. Williamson.)

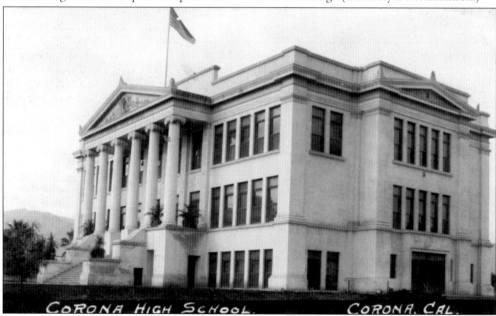

CORONA HIGH SCHOOL, 1907. Admiring Coronans observed that, from a distance, the school had the appearance of marble. Entering students wrote in their student publication, *La Corona*, "My! How fine it is in this big, new building of ours. We can now want for nothing more in the way of advantages." A grand auditorium, used for both school and community purposes, was located straight ahead once one entered the front doors. (Courtesy D. Talbert.)

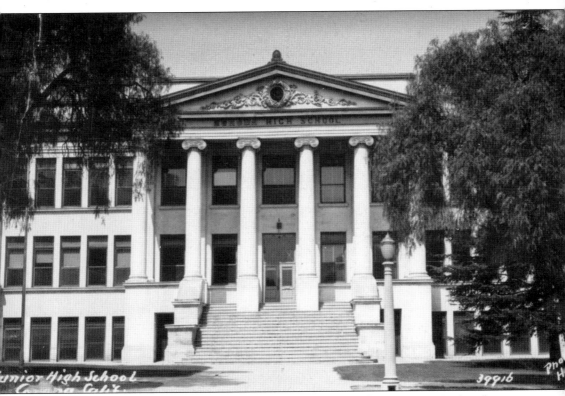

CORONA JUNIOR HIGH SCHOOL, C. 1936. This building, with its massive Ionic columns, served as the first Corona High School from 1907 to 1923 when overcrowding (350 students in facilities intended for 180) led to a larger high school being built on West Sixth Street. After 16 years as a high school, the five-acre site was converted to Corona Junior High School in 1923. At this time, according to old school board minutes, the roof was removed and redone at a cost of $125. Miss Letha Raney served as the principal. In January 1939, the second story was declared unsafe and was no longer used for instruction. From 1940 to 1941, the building was condemned, fenced off, and was torn down as a WPA project. (Courtesy author.)

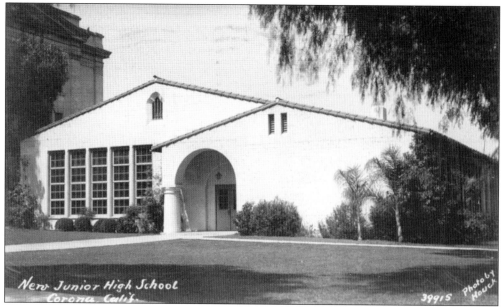

New Junior High School
Corona Calif.

39915 Photo by Houck

CORONA JUNIOR HIGH SCHOOL, C. 1938. This is the "new" Mission Revival structure added to the campus in 1936. Today it houses the library, cafeteria, and classrooms and abuts West Grand Boulevard on the right. Reinforced concrete was used in construction and the wood-grain pattern of planks, used to form the walls, are visible to the naked eye. In this postcard view, the two-story building has not yet been demolished. (Courtesy author.)

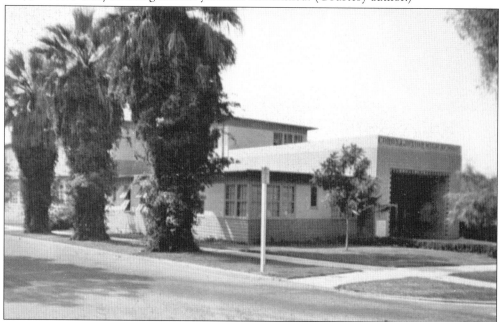

CORONA JUNIOR HIGH SCHOOL, C. 1956. Built in 1948, this administration building and two-story classroom structure is still in use today, located on the northwest corner of Main and Olive Streets. The palms along Olive Street are no longer there. A historic marker, in recognition of this campus serving as Corona's first high school and junior high, was placed by the Corona Historic Preservation Society and dedicated May 12, 2000. (Courtesy author.)

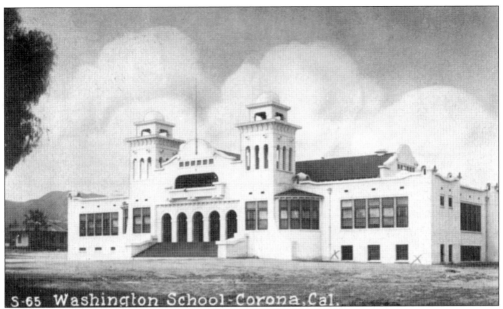

S-65 Washington School-Corona, Cal.

WASHINGTON GRAMMAR SCHOOL, C. 1915. Once located on West Grand Boulevard, this Mission Revival structure was designed by Leo Kroonen Sr. and totaled 14,000 square feet. The main entrance was through a portico, and the library sat directly above the entrance. It opened in September 1911 and continued to educate the youth of Corona for almost 40 years until 1950, when it was deemed unsafe and demolished. (Courtesy author.)

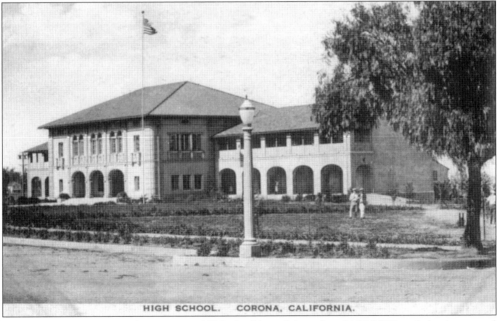

HIGH SCHOOL. CORONA, CALIFORNIA.

SECOND CORONA HIGH SCHOOL, C. 1928. Amid much hoopla, a $150,000 bond election passed in January 1922 by a margin of 10 to 1 to build a new campus. Four locations were considered before a $9,450, 12.5-acre site was selected by a postcard canvass (a survey mailed on postcards) of Corona's citizens. At the time, barley fields occupied the site. When this Mission Revival structure opened its doors in 1923, the entire community celebrated. (Courtesy D. Williamson.)

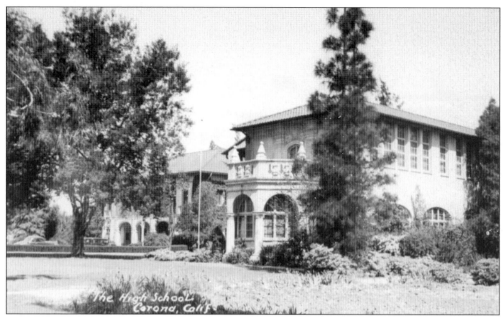

CORONA HIGH SCHOOL, C. 1940. In 1931, the east wing, with its classrooms and library, was added to the campus. The first-floor library's semicircular reading area is located behind the arched windows below the column-supported balcony. On the upstairs balcony wall is found a magnificent education-themed, coat-of-arms stone carving featuring a male and a female student, books, and the Lamp of Learning. (Courtesy author.)

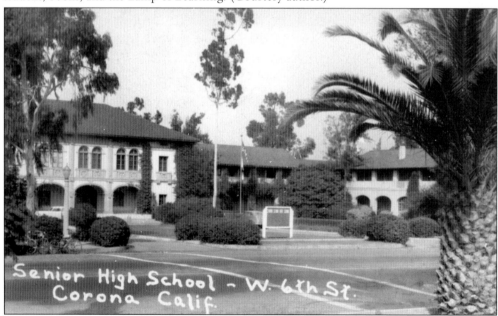

CORONA HIGH SCHOOL, C. 1950. The east wing classrooms can be seen where they connect to the main building. This postcard image is from the south and west and includes a good view of the circular driveway that reached the main building's entry arcade. A circular fountain designed by Ken Kammeyer, with tile supplied by Jordan Tile Company on Railroad Street, replaced the driveway in the late 1960s. (Courtesy author.)

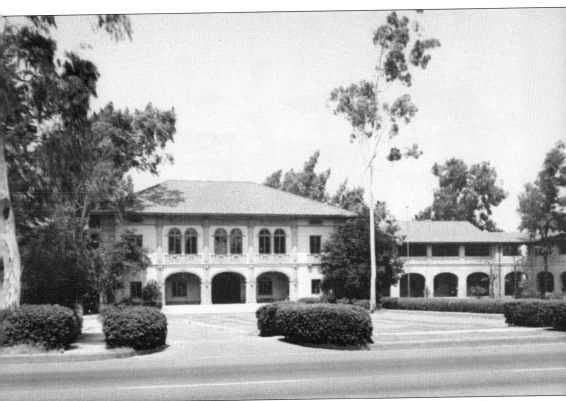

CORONA HIGH SCHOOL, 1950s. Riverside architect of renown, G. Stanley Wilson, designed all major buildings on this campus. He also served as architect for the library wing at Jefferson School as well as buildings at the Riverside's Mission Inn and the Norconian Club in Norco. The Domestic Science or Home Economics Building was erected in 1923 along with the main building. The Physical Education Building, now the City Gymnasium, was added in 1927. This complex served as the Corona City Hall from 1962 until May 2005 when the "new" city hall opened on the north side of the Civic Center complex. With approval of the city of Corona, the owner of this complex, the author Mary Winn and her husband, Richard, completed the paperwork to nominate Corona High School for the National Register of Historic Places on behalf of the Corona Historic Preservation Society. This prestigious designation was officially awarded on August 3, 2005. The buildings seen here are utilized in 2006 as office space for local non-profit organizations. (Courtesy author.)

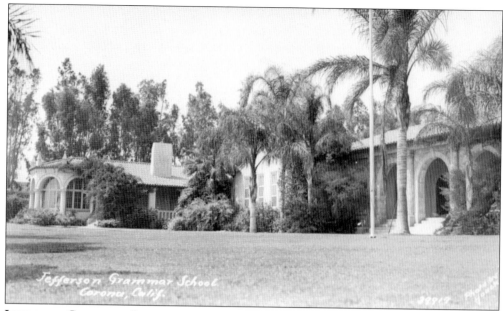

JEFFERSON GRAMMAR SCHOOL, C. 1937. Built in the Mission Revival style in 1927, Jefferson has educated Corona students for nearly 80 years. Designed by architect W. Horace Austin of Long Beach, the mixture of cut-stone arches, plastered walls, and arched windows, along with the lush foliage, give a timeless quality to the campus located at Tenth Street and Vicentia Avenue. A Corona Historic Preservation Society historic marker was dedicated here on March 13, 1998. (Courtesy author.)

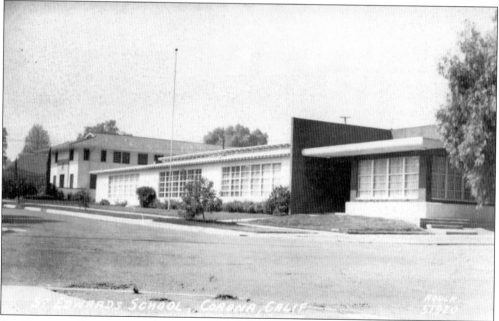

ST. EDWARD SCHOOL, C. 1957. St. Edward School is a private Catholic school located at 500 Merrill Street. The school's first building opened in 1947 with four classrooms, and other buildings joined the campus as grade levels were added. Currently students from preschool to eighth grade attend the school. (Courtesy author.)

Five

RESIDENCES

AND RANCHES

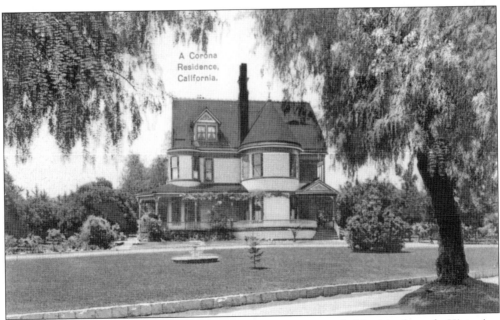

JOY RESIDENCE, 1910S. City founder George L. Joy erected this shingle-style Victorian around 1890 at 1127 East Grand Boulevard. The second story and attic were later removed. From Iowa, Joy was the primary investor and president of the South Riverside Land and Water Company and was instrumental in the formation of the citrus industry. His daughter Hetty married W. H. Jameson, who continued the prosperous family business. (Courtesy D. Williamson.)

RESIDENCE STREET, C. 1905. The view here is looking north on Ramona Avenue from near the corner of Eleventh Street. The decorative Victorian house on the left, 1022 Ramona Avenue, is the same house as in the postcard below but from a different angle and before extensive modification to the exterior was done. This neighborhood was considered to be quite fashionable when it was built in 1890. The steeple of the original Methodist church is in the background. (Courtesy author.)

BROWN'S CORNER, C. 1920. Located at 1022 Ramona Avenue was the attractive home of Mr. and Mrs. George Brown, or "Brown's Corner" as seen on the postcard. Note the addition of the enclosed sun porch, the enclosure of the upstairs balcony, a change in handrails, and the variety of windows. The decorative fascia on both gables can still be seen today. George Brown served as Corona's postmaster from 1902 to 1909. (Courtesy Corona Public Library.)

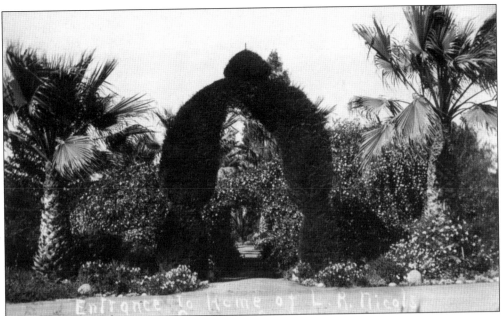

ENTRANCE TO RHODY RANCH, C. 1908. L. R. Nichols established this ranch off Chase Drive in the late 1800s and named it for his home state of Rhode Island. The ranch property is located in the area formerly known as Orange Heights near the intersection of Chase Drive and Hudson Street. Nichols once owned the land that became Corona City Park. (Courtesy author.)

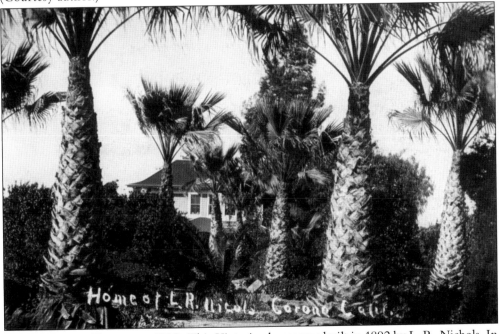

L. R. NICHOLS HOUSE, C. 1908. This Victorian home was built in 1892 by L. R. Nichols. In March 2006, a fire broke out and damaged the architectural masterpiece hidden behind palm trees in this postcard. The current owners have lived here for 40 years and plan to rebuild and restore the home to its previous glory. (Courtesy D. Talbert.)

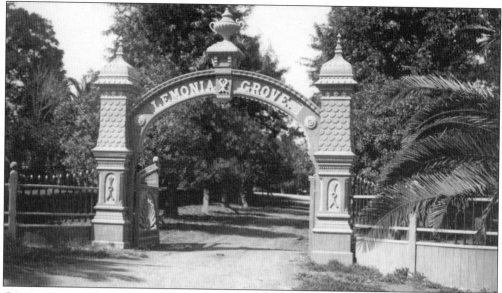

CHASE DRIVE ENTRY TO LEMONIA GROVE, C. 1906. This was the guest entry to Oscar Thieme's 26-acre estate. He built a packinghouse to process fruit from his groves as well as a two-story Victorian carriage house in 1895. The Thieme family occupied the second floor. Oscar's plans for the property were never fulfilled, and he returned to Germany before World War I. The property, purchased by W. H. Jameson, was used for social events. (Courtesy S. Lech.)

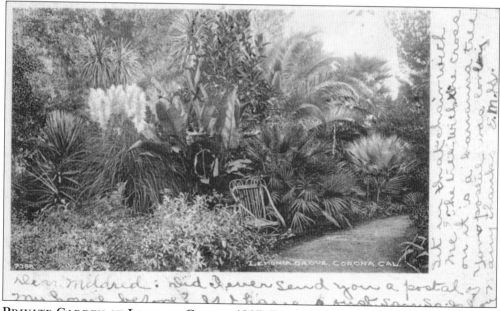

PRIVATE GARDEN AT LEMONIA GROVE, 1907. Beginning in 1895, German businessman Oscar Thieme collected and planted an abundance of rare trees, flowers, and plants along landscaped trails and walkways to remind him of his European homeland and places he had visited. On the back of the postcard, the message concludes with the following: "Don't you wish you could sit in that chair with me? The tree with the cross is a banana tree." (Courtesy author.)

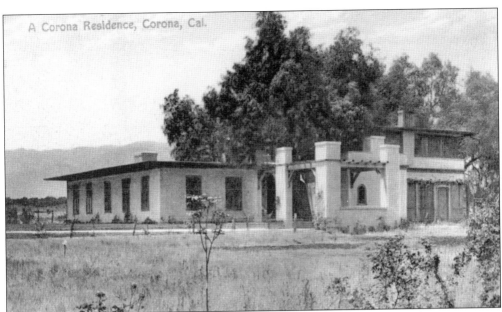

ADOBE RESIDENCE AT 1130 GARRETSON AVENUE, C. 1910. The walls of this adobe home, built in 1905 by Mexican artisans, are 18 inches thick and provide excellent insulation. A benefit of adobe is that no matter how hot it is outside, it is always much cooler inside. This home still stands and is located on the west side of Garretson Avenue where it meets with Park Lane. It is one of only a few adobe structures remaining in Corona. (Courtesy author.)

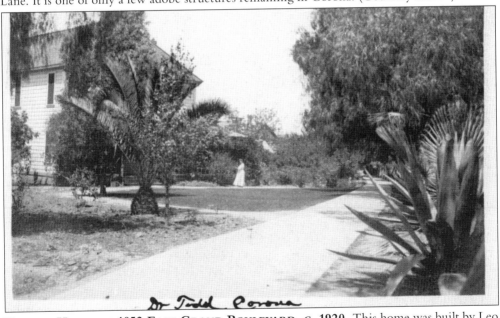

HUDSON HOUSE AT 1052 EAST GRAND BOULEVARD, C. 1920. This home was built by Leo Kroonen Sr. in 1888 for prominent citizen N. C. Hudson and his wife, Helen. Dentist Robert A. Todd and his family were the next occupants. In this postcard, Dr. Bernice Jameson Todd, who lived to be 102, stands in the circular driveway of her brother-in-law's home. She lived across the street and was well known for the many years she worked within the schools to improve the health of children. (Courtesy N. Benvenuti.)

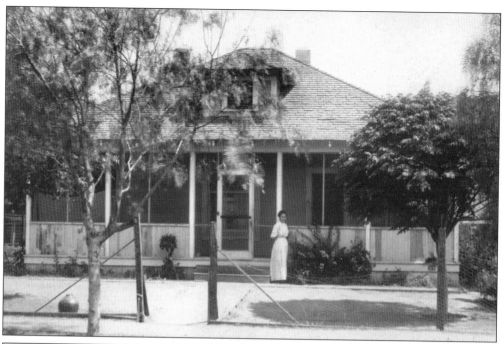

STURDY BUNGALOW, C. 1910. The precise location of this home is unknown, but it looks to have been built around 1910. It has a hipped roof, a dormer, two chimneys, and a screened front porch. During times of intense heat, folks often slept on porches to take advantage of the cooler temperatures outside. The fence is made of chicken wire, and a young pepper tree is in the foreground. (Courtesy Corona Public Library.)

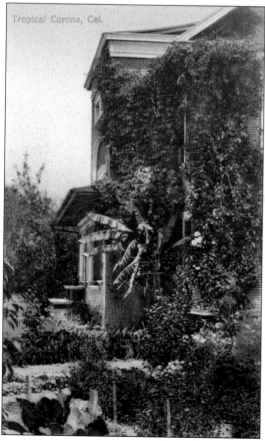

TROPICAL CORONA, C. 1915. Lush vegetation of a great variety is seen here at 1136 East Grand Boulevard. The postcard was made in Germany. Built in 1905, this elegant structure, although modified over the years, still graces the circular boulevard at the northeast corner of Victoria Avenue and East Grand Boulevard. (Courtesy author.)

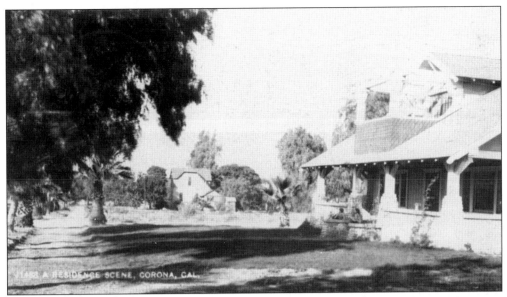

RESIDENCE SCENE, 1917. This view is looking north from the east side of Main Street just south of Olive Street. The house on the right is 1301 Main Street, built around 1910. Fred and Adora B. Snedecor and their children, Adoralou and Robert, lived in this home for many years, starting in 1928. The back of this postcard reads, "Dear folks, Got home all right. Antie [sic] was pretty well for her. Bernals all had colds." (Courtesy author.)

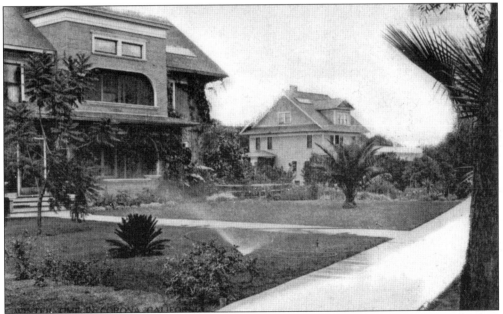

WINTER TIME IN CORONA, C. 1910. The homes pictured here were built in 1905. Their addresses, from left to right, are 1136 and 1122 East Grand Boulevard. The W. J. Pentelow house is on the left. He was the president of the Board of Trade in 1902, served as the tree warden in 1913, and was mayor in 1914. A third home, 1128 East Grand Boulevard, was built between the two structures in the late 1920s. (Courtesy D. Williamson.)

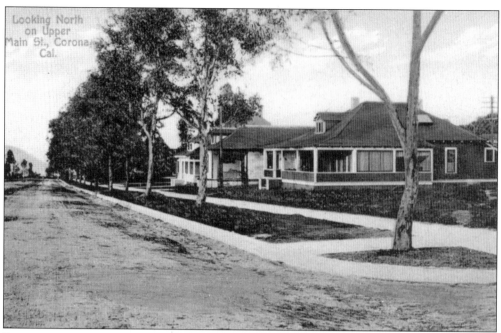

LOOKING NORTH ON UPPER MAIN STREET, 1920S. Upper Main Street is found in south Corona where it approaches the Cleveland National Forest. The exact location of this postcard image is unknown, but the homes undoubtedly were razed at some point to make way for new development. (Courtesy D. Williamson.)

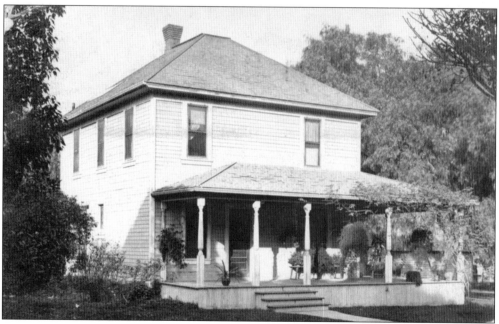

1911 HOME. "This is of the house in Corona, Calif." is written on the back of this postcard. It is a two-story house with a hipped roof and a wide wraparound front porch. Its location has not been determined, so perhaps the house was remodeled or met its demise to make way for new construction. It is very typical of homes built a century ago. (Courtesy D. Talbert.)

NORTHWEST CORNER OF ONTARIO AVENUE AND MAIN STREET, 1949. This spectacular photograph was taken by Corona photographer Rudy Ramos of the spacious Scoville House, named for the Frank and Kate Scoville family. It is an example of American Foursquare/ Colonial Revival architecture and was constructed in 1894. For many decades, the home served as a landmark for travelers. It was destroyed by fire in the 1990s. (Courtesy Corona Public Library.)

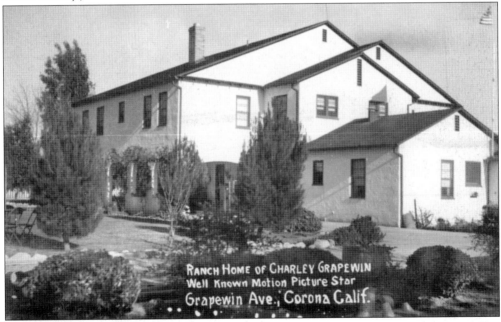

RANCH HOME OF CHARLEY GRAPEWIN, c. 1940. Grapewin, a vaudeville, stage, and film actor, played Uncle Henry in *The Wizard of Oz* and Grandpa Joad in *The Grapes of Wrath*. His large residence was located on Grapewin Avenue next to the Fuller Rancho where Eastvale is today. Most of the home burned in 1973 but was repaired only to be demolished by a developer in 2004. (Courtesy D. Williamson.)

A Vista in January at Ben White's Foothill Corona Ranch, Corona, Cal.

BEN WHITE'S FOOTHILL CORONA RANCH, C. 1901. This ranch was located at the southern end of Main Street a century ago and overlooked the entire area. The handwritten message on the back of this postcard reads, "California is more charming than ever. Roses are blooming and I am succumbing to the attractions of the climate. Love to all, Elizabeth." With no landscaping, the residence appears to be newly constructed. (Courtesy D. Williamson.)

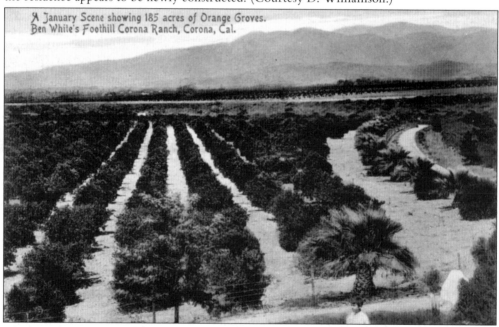

A January Scene showing 185 acres of Orange Groves. Ben White's Foothill Corona Ranch, Corona, Cal.

JANUARY SCENE AT BEN WHITE'S GROVES, C. 1901. From a southeasterly perspective, the seemingly endless rows of orange trees are captured in this postcard. The Santa Ana Mountains provide a backdrop for 185 acres of groves. The gravel road at the right, lined with young palms, indicates this view may have been taken from near the ranch house pictured above. Note the child in the foreground. (Courtesy R. Harris.)

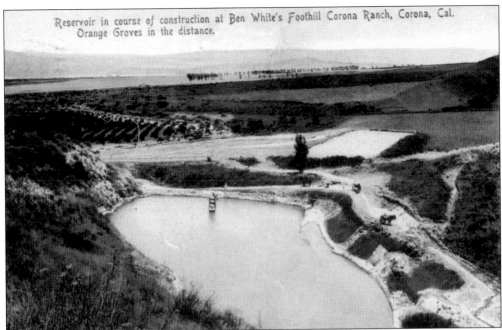

Reservoir in course of construction at Ben White's Foothill Corona Ranch, Corona, Cal. Orange Groves in the distance.

RESERVOIRS UNDER CONSTRUCTION AT BEN WHITE'S RANCH, C. 1901. "Water is King" was a phrase often uttered when referencing Corona's agricultural industry, for it was the lifeblood of the community. As the population continued to grow, so did the need for reliable sources of water. Reservoirs were under construction in both postcard images. From these reservoirs, irrigation ditches and culverts provided life-giving water to the trees on the property. The above view looks in a northeasterly direction toward Corona with Beacon Hill in the background. The trees indicate the location of new development within the Grand Boulevard Circle. Below, the image looks east toward the Santa Ana Mountains. Note the workers and horses on the road to the right of the reservoir. (Above courtesy D. Williamson; below courtesy R. Harris.)

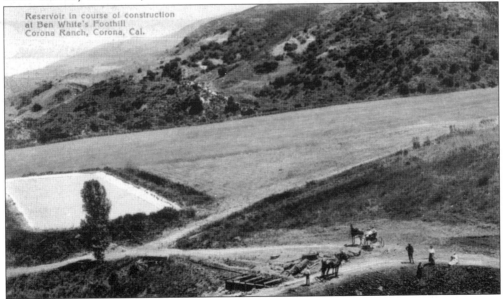

Reservoir in course of construction at Ben White's Foothill Corona Ranch, Corona, Cal.

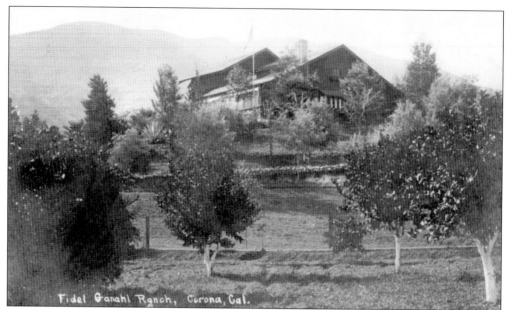

FIDEL GANAHL RANCH, *C.* 1920. Ben White sold his ranch to Fidel Ganahl in 1915 for more than $100,000. This home appears to be a remodeled version of the original Ben White home seen in the upper image on page 92; the landscaping has matured. This ranch produced lemons, oranges, grains, and alfalfa. (Courtesy author.)

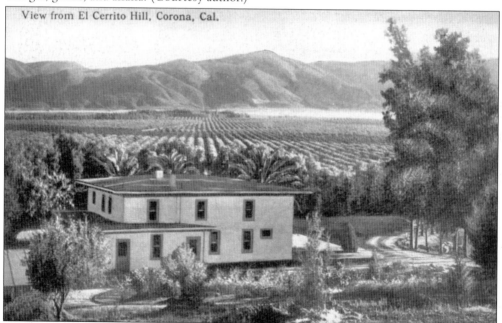

EL CERRITO RANCHO, *C.* 1910. City founder R. B. Taylor planted 14,000 lemon and orange trees in 1893, establishing "the little hill" ranch on 155 acres to the southeast of Corona proper. In 1896, Taylor sold his holdings to Baroness Hickey. Wealthy New Yorker J. H. Flagler later acquired the estate for $76,078. Francis Stearns purchased the property in 1945, subdivided it, and called it El Cerrito Village. This view is looking south toward the Santa Ana Mountains. The home still exists. (Courtesy S. Lech.)

Six

HOMETOWN PRIDE

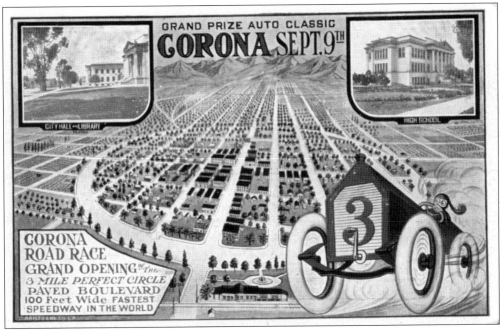

PROMOTIONAL POSTCARD, 1913. The Corona Chamber of Commerce and Corona Auto Association printed 20,000 of these three-color postcards advertising the first Corona Road Race. They were distributed free to anyone who would mail them, and Monday, August 18, 1913, was designated "Corona Post Card Day." Everyone was urged to send as many as possible on this day, and a *Corona Daily Independent* article urged Coronans to "literally swamp the local post office if it is possible to do so." (Courtesy D. Talbert.)

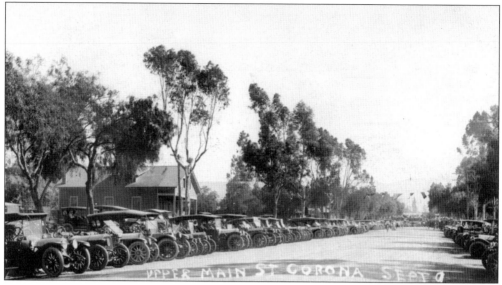

UPPER MAIN STREET ON RACE DAY, 1913. The motto of the race was "Safety First" (the race itself had two accidents but no injuries) and this applied to spectators' rules as well as the race drivers. The curbs on Main Street south of Olive Street were used as parking blocks for rear tires of many of the patrons' personal vehicles so they could leave the area without putting cars in reverse. (Courtesy D. Williamson.)

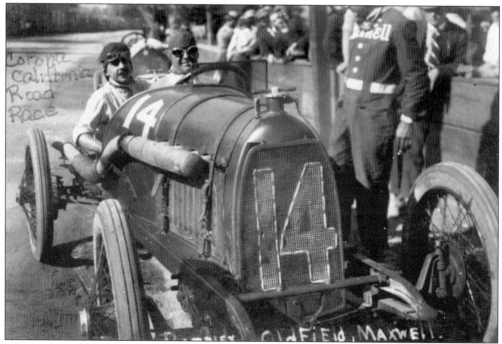

BARNEY OLDFIELD IN NO. 14, 1914. Oldfield is behind the wheel of his Maxwell with his "mechanician" Harry Goetz. Oldfield did not win, but after the 10th lap, he was never lower than fifth place. He managed to record the fastest lap ever made on the track while nursing his "sick" Maxwell around the course without taking a pit stop. This feat turned out to be a new world nonstop record. (Courtesy D. Williamson.)

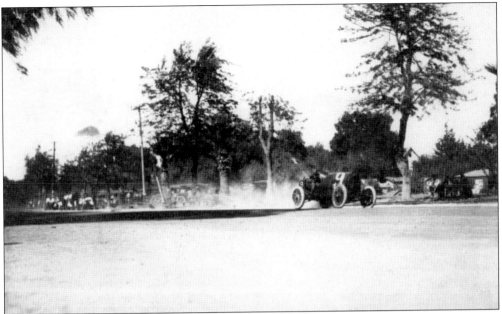

RACE CAR IN ACTION, 1913. In 1913 race, Teddy Tetzlaff drove car No. 9, which was called "the big Fiat." There was a great deal of competition between the American and the foreign cars even then. The back of the postcard reads, "This picture is Brother Teddy (Tetzlaff) at the Corona race. He is going the rate of 95 miles an hour as this was taking [sic]." (Courtesy D. Talbert.)

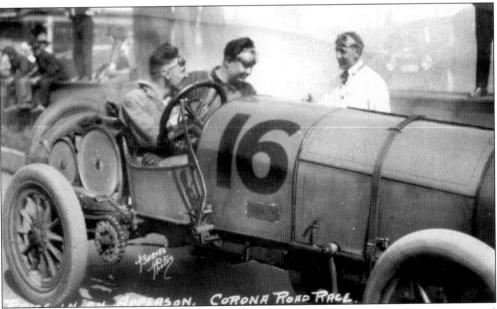

PRICE IN AN APPERSON, 1916. In his final practice run, Sam Price, while speeding around the course at 95 miles per hour, struck a palm tree and his car caught fire. Price, who was badly injured, would recover but not in time for the race. This incident was one of several attributed to the "jinx" of the 1916 race, where small incidents occurred that put competitive cars and drivers out of the race before it had even begun. (Courtesy N. Benvenuti.)

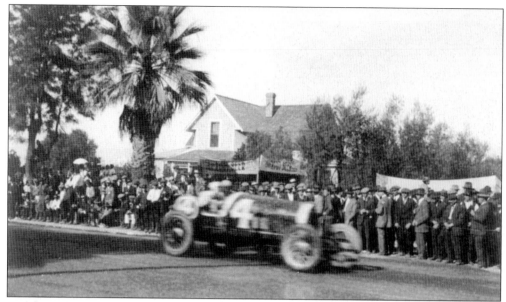

EDDIE PULLEN IN HIS MERCER, 1914. Between the 70th and 80th lap, Pullen took the lead and never relinquished it. His time was 3 hours, 26 minutes, and 2 seconds. He won the $6,000 winner's prize and averaged 87.76 miles per hour. The author of this postcard message wrote, "Auto race Corona, Calif. Thanksgiving Day 1914 Eddie Pullen winner going over 92 mi per hr (in a) Stutz car." (Courtesy author.)

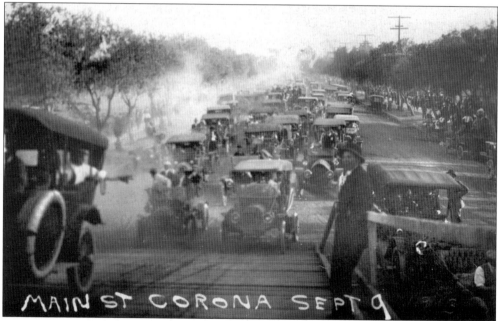

POST-RACE TRAFFIC JAM ON MAIN STREET, 1913. Amidst clouds of dust and exhaust fumes, 15,000 cars departed Corona within two hours after the finish of the race. The driver of the car in the left foreground uses a hand signal to indicate his desire to change lanes. With the open cars of that time, rubbernecking and body contortions of drivers and passengers were clearly seen. (Courtesy Corona Public Library.)

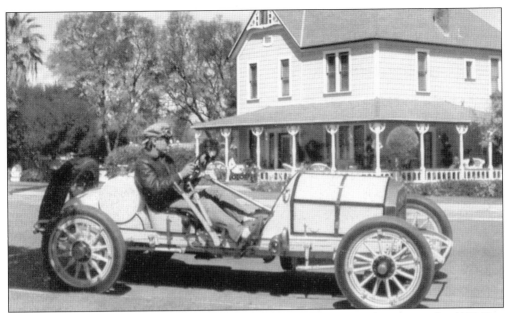

ROAD RACE RECOGNITION, MARCH 2002. A 1913 Mercer Raceabout passes by 1052 East Grand Boulevard on March 23, 2002. Television celebrity Huell Howser and his crew brought two race cars of that era to Corona. They filmed an episode for the PBS series, *California's Gold*, the same day the Corona Historic Preservation Society dedicated a historic marker at the start-finish line, commemorating the races. (Courtesy E. Montanez.)

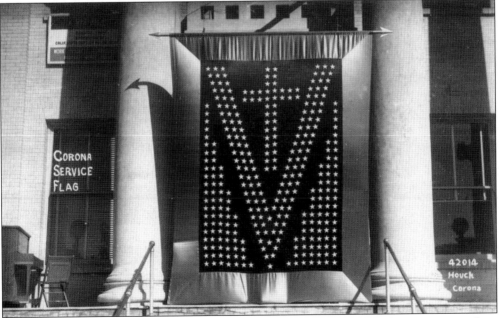

WOMEN'S VICTORY SERVICE FLAG, 1942. In 1942, after the bombing of Pearl Harbor, representatives from Corona's women organizations created this flag, each star representing a citizen from the Corona-Norco area who served in the military. Here the banner is hanging on the front steps of Corona's first city hall. By the end of the war, 1,005 Corona-Norco area men and women had served in the military. (Courtesy Corona Public Library.)

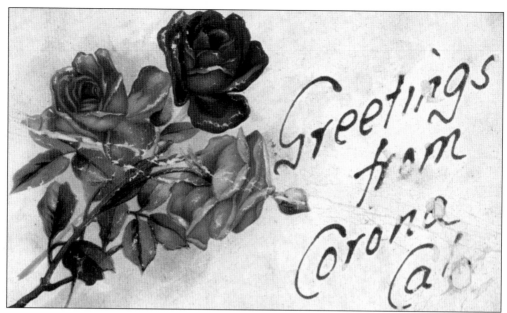

HAND-PAINTED GREETINGS, 1908. Personal correspondence, adorned with elaborate handwriting and detailed images, was once a form of art shared with loved ones and others. This hand-painted rose appears to be created with pink and green watercolor. Some one-of-a-kind postcards were embroidered and became treasured mementos. (Courtesy Corona Public Library.)

HOME OF NATIONAL ORANGE SHOW, SAN BERNARDINO, C. 1920. The first National Orange Show was held in 1911, with tents pitched at Fourth and D Streets in San Bernardino, and the event has taken place every year since except for four years during World War II. Creative citrus displays once graced the interior of this lavishly landscaped event center. Although Corona is known for lemon production, many outstanding entries showcased its juicy oranges as well. (Courtesy author.)

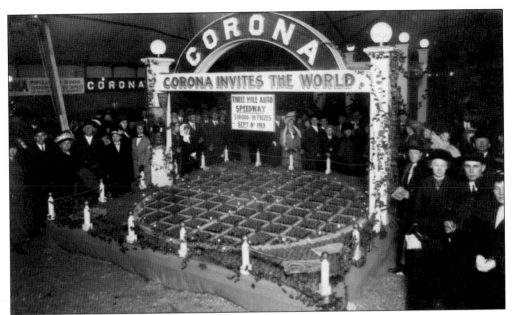

NATIONAL ORANGE SHOW, FEBRUARY 1913. This promotional exhibit invites all to attend Corona's first road race in September 1913 and shows an elaborate grid representing the heart of Corona encircled by the Grand Boulevard "speedway." The miniature version of the city features oranges, streetlights, and vehicles along the circular track. "Three mile auto speedway, $10,000 in prizes, September 1913" can be seen on the suspended sign. (Courtesy D. Williamson.)

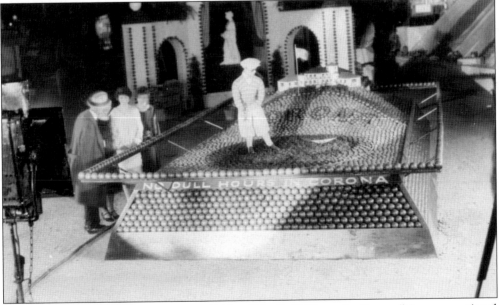

NATIONAL ORANGE SHOW, EARLY 1960s. "No Dull Hours In Corona" is a promotional display incorporating oranges and lemons. It features a golfing mannequin in vintage cap and knickers attempting to sink a putt. A replica of Parkridge Country Club sits atop the hill. The clubhouse, built in 1925, once sat where Cresta Verde Golf Course now resides. Onlookers' attire suggests it is the early 1960s. (Courtesy R. Harris.)

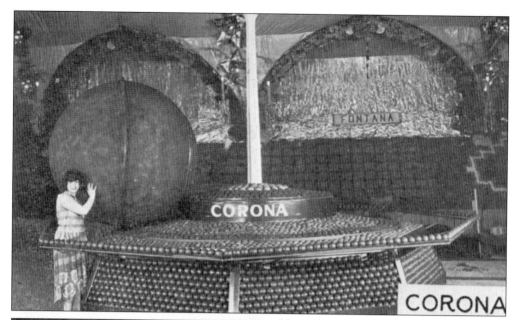

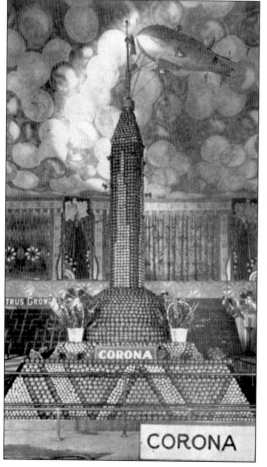

NATIONAL ORANGE SHOW, 1928. Circles, orbs, and other rounded shapes appear in this unique exhibit from the Circle City. A young woman is seen ready to launch the globe, thought to be covered in orange peel, along the circumferential track. Note Fontana's display in the background. (Courtesy author.)

NATIONAL ORANGE SHOW, 1930. Oranges, lemons, and limes were utilized in this incredible representation of the Empire State Building. A model of a dirigible is supported from the bottom by steel rods projecting from the mast atop the New York City landmark. Both are seen here with a citrus-themed covering of the arena's arched ceiling. (Courtesy author.)

NATIONAL ORANGE SHOW, 1931. As the years went by, the degree of detail of the exhibits increased with amazing results. This replica of the Taj Mahal, complete with minarets, must have wowed the crowds attending the annual convocation. The front of the postcard describes the historical significance and architectural elements of the site in Agra, India, "Built of the purest white marble, and with unequalled perfection in workmanship, it is classed as the most beautiful building in the world." (Courtesy author.)

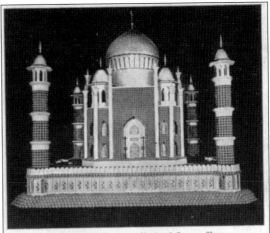

Corona Exhibit at 21st National Orange Show

Taj Mahal, Agra, India

Pronounced: Taash Mahal. Meaning: The Crown of Palaces.

THE Taj Mahal was built by the Moslem Emperor, Shah Jehan, in memory of, and as a tomb for his wife, Mumtaz-i-Mahal (The Light of the Palace).

Built of the purest white marble, and with unequalled perfection in workmanship, it is classed as the most beautiful building in the world.

The marble platform upon which the tomb itself rests, covers more than two acres; the four minarets gracing the corners of the platform are 150 feet high. The tomb, surmounted by the central dome of over 200 feet elevation, occupies three-fourths of an acre in the central part of the platform.

Its completion required the expenditure of $35,000,000 and the services of 20,000 workmen for nearly 20 years. To provide for maintenance after completion, the revenue from 30 Moslem villages was set aside for the purpose. At present, however, the British Government provides a special board which is directly charged with its care.

A noted Bishop said: "It would be as easy to tell how birds sing or how lilacs smell, as to describe the Taj."

LOS ANGELES COUNTY FAIR, 1949. A roadside lemonade stand, or diorama, complete with an umbrella, cashier, and two children customers, showcases Corona's "Lemon Capital of the World" image. A Queen Bee label, designed in 1893 for the Queen Colony Fruit Exchange Packinghouse in Corona, is affixed to the lemon crate. (Courtesy D. Talbert.)

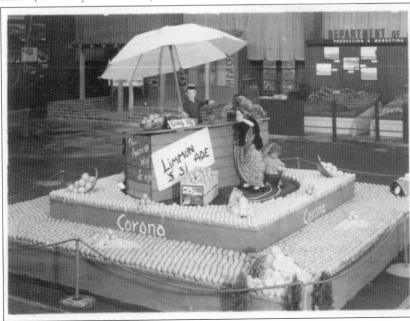

America's

Largest

Most

Beautiful

County

Fair

400 enchanted acres and over 200 permanent buildings. Ample parking for 35,000 cars.

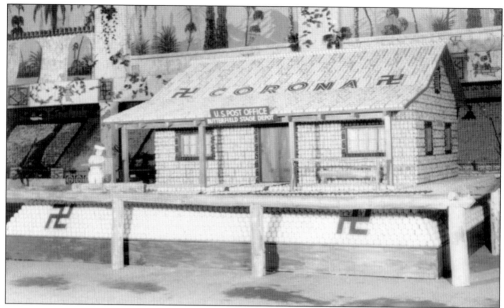

NATIONAL ORANGE SHOW, 1933. The Butterfield Stage era was short-lived and only lasted from 1858 to 1861. Portrayed here is a Butterfield Stage Depot and U.S. Post Office fashioned out of oranges. From the station stop at Glen Ivy, the stage carrying mail passed at breakneck speed through Temescal Canyon and the Corona area until the next stop near the Prado Dam, heading for Los Angeles and San Francisco. For centuries, the swastika was a popular symbol used by many cultures, including Native Americans, until it came to represent Hitler and the Nazi Party. The symbol now represents evil, and many discontinued its use as ornamentation. (Courtesy author.)

NATIONAL ORANGE SHOW, 1933. A variety of displays are seen in this postcard. Corona's is in the lower right, Colton is on the left, and Los Angeles County's entry is in the center. (Courtesy author.)

Seven

OUTLYING AREAS
AND RESORTS

YORBA AND SLAUGHTER FAMILIES ADOBE, 1980S. Built in 1852–1853, it is one of the oldest standing adobe residences in San Bernardino County and is named for the two families who once resided there. The structure stands to the east of Highway 71 near Euclid Avenue in the area now known as Chino Hills, and visitors may tour the adobe, a caretaker's home, a recreated post office and general store, and a large barn/winery building. (Courtesy S. Lech.)

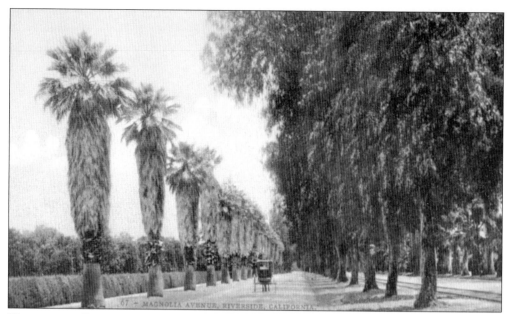

HORSE-AND-BUGGY ON MAGNOLIA AVENUE, 1915. This was once a single, unpaved road with collared palms growing on one side and pepper trees on the other. The Pacific Electric tracks parallel the roadway to the far side of the pepper trees. The social sections of local newspapers used to report when Corona residents traveled to Riverside and for what reason. (Courtesy author.)

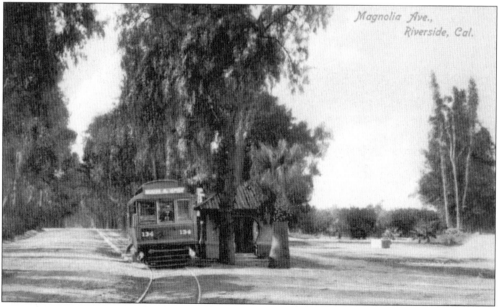

RED CAR ALONG MAGNOLIA AVENUE, C. 1920. Pacific Electric Red Cars provided connecting passenger rail service from Riverside to the Corona Station at Third Street and Main Street starting in 1915. The Red Car or trolley right-of-way followed Third Street until it passed outside Grand Boulevard, then angled toward Magnolia Avenue and followed the median on Magnolia into the outskirts of Riverside. Many longtime Coronans today recall using the trolley to visit Riverside. (Courtesy author.)

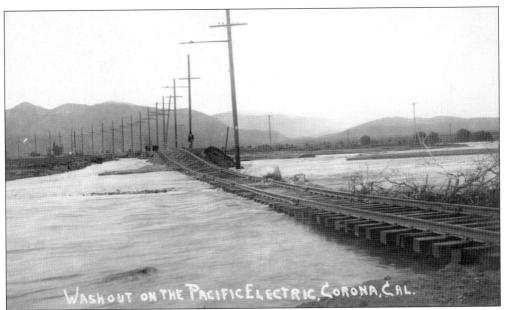

WASHOUT ON THE PACIFIC ELECTRIC, 1916. Pictured here are the undermined Red Car tracks along Third Street as they disappear eastward toward Magnolia Avenue. Power poles on the right follow the route of an undeveloped Sixth Street. The amount of water and extent of damage explain why there is now a large concrete flood-control channel in this area to handle water flows from Temescal Canyon into the Santa Ana River. (Courtesy R. Harris.)

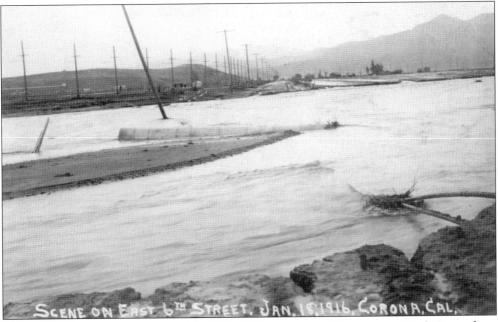

EAST SIXTH STREET, JANUARY 18, 1916. This view is looking east on Sixth Street from east of Main Street. Home Gardens is in the distance. The string of power poles to the far left parallels the Third Street route of the Pacific Electric track to Riverside. Lumber deliveries for Corona Lumber at Fourth and Main Streets traveled down these PE tracks to a siding where they could be unloaded. (Courtesy R. Harris.)

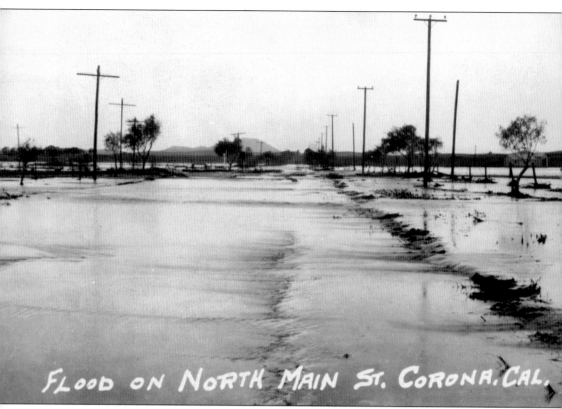

FLOOD ON NORTH MAIN ST. CORONA, CAL.

FLOOD ON NORTH MAIN STREET, 1916. This view was taken north of the Santa Fe Railroad tracks. River Road branches off Main Street near the tree to the left of center at "Y Corner," called so because the angle of the intersection created a "Y." The water-well pump equipment can also be seen here. In 2006, the pump equipment is on the east side of Main Street where it meets River Road. The intersection of Parkridge Avenue and Main Street is located in front of the trees in the center of the postcard image. Beyond Parkridge, pepper trees line Hamner Avenue. Beacon Hill, in the distance, was used by Norco founder Rex B. Clark for promotional purposes. At one time, a light was placed there to beckon all to come to Norco and, of course, his Lake Norconian Club. (Courtesy R. Harris.)

FERNS, C. 1918. The canyons southeast of Corona were once teeming with lush ferns due to the abundance of water at or near ground level. Plant life has changed over time as the level of the water table has become significantly lower. (Courtesy author.)

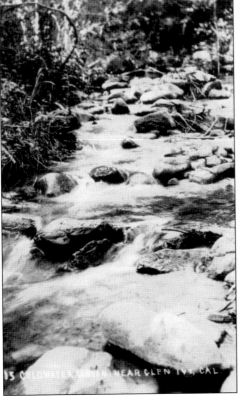

COLDWATER CREEK NEAR GLEN IVY, C. 1915. Coldwater Canyon is the largest canyon on the north side of the Santa Ana Mountains south of Corona, and Coldwater Creek ran through the canyon for miles. It was tapped as a water source for agricultural purposes and a growing population. According to a 1902 advertisement, "The canyon is a lovely place and is visited by hundreds of picnic parties every year, both in the summer and winter." (Courtesy author.)

TEMESCAL CANYON, C. 1910. This area south of Corona is said to be one of the most picturesque valleys in Southern California. Ancient inhabitants, Native Americans from the missions, colonists and settlers, and the Butterfield Stage used the trail through Temescal Canyon. Early Corona high-school students went on picnics to this area via a "tally-ho," a popular mode of travel where people rode in a wagon with rows of seats and were pulled by a team of horses. (Courtesy author.)

GLEN IVY FROM AFAR, C. 1910. Visitors nearly a century ago were greeted with a picturesque sight of the hotel nestled against the trees. The sign atop the hotel proclaims the "Glen Ivy Hot Springs Hotel, Baths," built in 1879. In 1890, owners Mr. and Mrs. W. G. Steers named the hotel Glen Ivy due to the proliferation of wild grape ivy in nearby canyons. (Courtesy Corona Public Library.)

GLEN IVY FROM A NEARBY HILL, C. 1915. The Luiseño Indians enjoyed the cleansing waters flowing from the canyon. They built dome-shaped mud saunas or "sweat lodges" around hot springs in the area and used them in religious ceremonies. In fact, Temescal means "sweat lodge" in the Native American language. Additional structures and the rugged hills are also pictured here. (Courtesy author.)

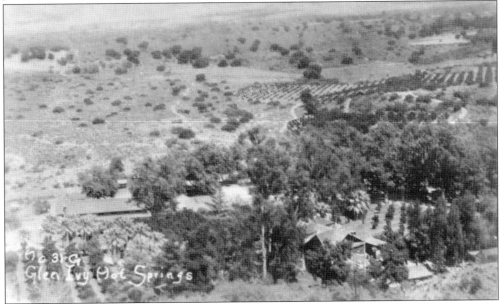

HILLSIDE VIEW OF GLEN IVY, C. 1915. The contrast between the natural foliage of the canyon entrance, planted groves, and the desert-like Temescal Canyon floor are pictured here. The first reference to commercial use of the rejuvenating waters appeared in the *Los Angeles Star* in September 1860. It was from an invitation for tired Overland Stage travelers to relax at the soothing Temescal Hot Springs, as it was known then. (Courtesy author.)

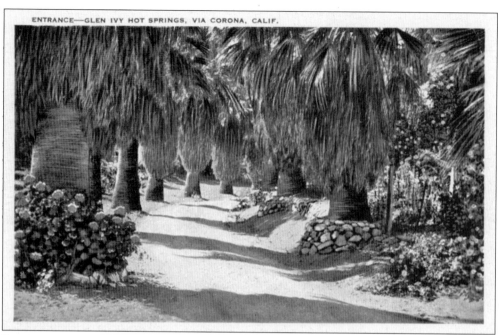

DRIVEWAY TO GLEN IVY ENTRANCE, 1941. Over the years, many celebrities and dignitaries entered Glen Ivy via this roadway lined with palm trees and lush plant life to partake of the waters at Glen Ivy. Paul Muni, W. C. Fields, and Presidents Roosevelt, Hoover, and Reagan were a few of the many guests. The collection of cabins and cottages provided guests with a measure of privacy not found in other more "civilized" resorts. (Courtesy author.)

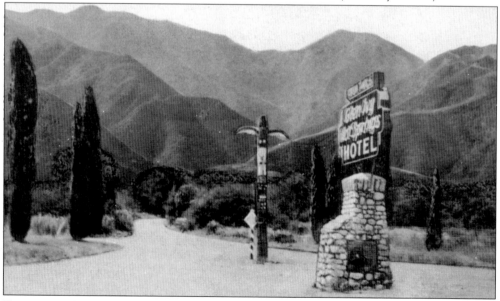

ENTRANCE GLEN IVY, MID-1920S. Located along Temescal Canyon Road approximately 10 miles southeast of Corona proper, drivers would come across this inviting sign marking the entrance to Glen Ivy Hot Springs. The foundation of the sign consists of river rock from a local streambed. Nearby is an eye-catching totem pole, unusual because totem poles are more often found in the Pacific Northwest. (Courtesy author.)

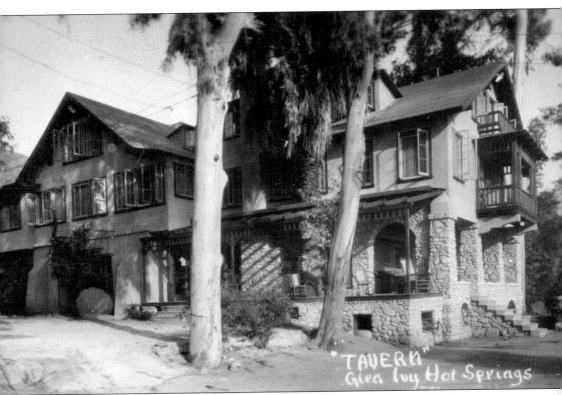

GLEN IVY TAVERN, 1930S. In the early 1870s, a Mrs. Thorndyke homesteaded on property around the springs and built the original hotel. The Steers were the next owners. Mabel and Frank Johnson purchased the property in 1913 and guided it through continued development as a resort. This building served as the hotel and reception area. Promotional wording from the back of this postcard states, "Glen Ivy Mineral Hot Springs via Corona. Beautifully located at the foot of Santiago Peak in Temescal Canyon, Glen Ivy Mineral Hot Springs boasts an ideal climate. The bracing mountain air, delightful hikes and excellent meals, combined with the curative Mineral Hot Baths and the excellent Massage Treatment makes this an ideal place for rest, relaxation and healthful enjoyment. Sixty miles from Los Angeles, paved Boulevard all the way. Moderate rates." (Courtesy D. Talbert.)

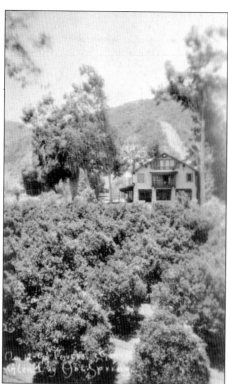

GLEN IVY TAVERN, 1920s. The side of the tavern amid citrus groves can be seen during the Johnsons' era. They enlarged the original hotel, built a bathhouse, added guest cottages, established a dirt airstrip along Glen Ivy Road, and brought in electricity and natural gas for cooking. The resort flourished under their stewardship, which lasted 25 years. (Courtesy author.)

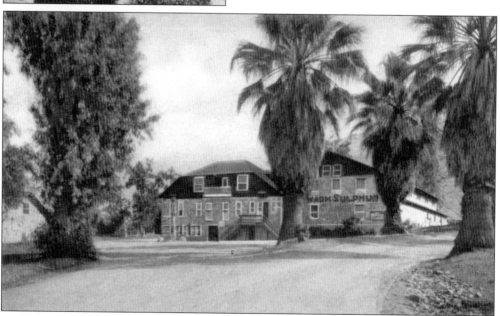

SULPHUR PLUNGE AT GLEN IVY, MID-1920s. In addition to the mineral baths, "scientific massages, combined with the purifying action of the hot sulphur water plunge" were advertised to be very beneficial to visitors' health. This tile building was added to the resort when Frank and Mabel Johnson were the proprietors. Quoting promotional materials of that time, Glen Ivy was a "health resort amidst beautiful surroundings and refined patronage." (Courtesy D. Talbert.)

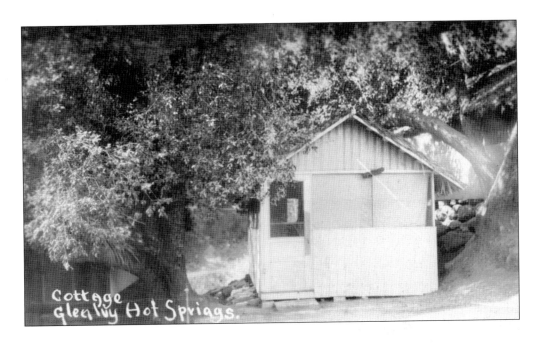

GLEN IVY COTTAGES, 1920s. Small but cozy lodging was provided in cottages set amid live oaks, sycamores, and palms. They were added early on to increase the capacity of the resort as well as to allow privacy for guests. Advertising materials from the past indicate many doctors patronized the resort and referred their patients to Glen Ivy for treatment and recuperative purposes. From the screened porches of the cottages seen here, guests were able to view a wide panorama of the surrounding mountains, woods, and orange groves while relaxing and hiding from mosquitoes and other pesky insects. (Courtesy author.)

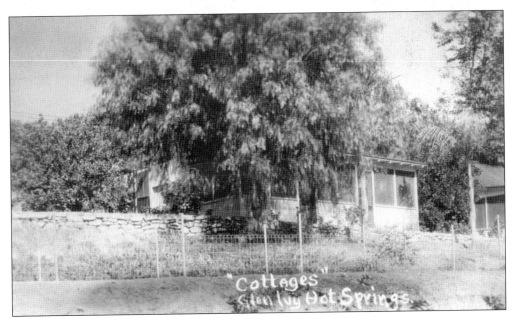

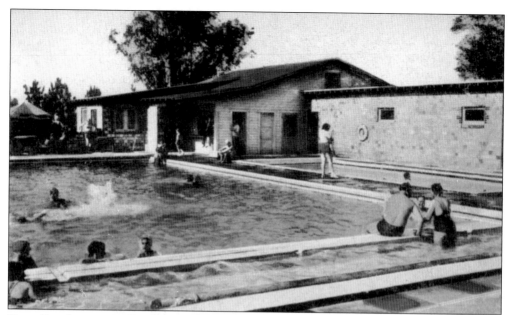

GLEN IVY SWIMMING POOL, C. 1940. In the 1890s, when the hot springs began evolving into a resort, the cost of a swim was 25¢, including a bathing suit and towel. Guests were able to swim all year due to the warm temperatures of the hot springs, which varied from 85 to 103 degrees Fahrenheit. This swimming pool, added in the late 1930s, also used the hot springs as its water source. (Courtesy author.)

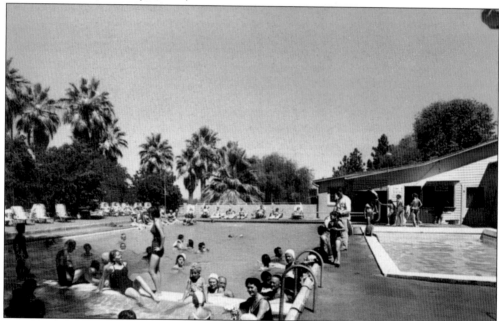

GLEN IVY SWIMMING POOL, 1962. The sender of this postcard wrote, "Decided to come here and leave the world roll by for a while. It is so lovely here, even a few days rest is a big help. You folks ought to do it sometime." A Corona resident, who swam here during the mid-1960s, recalls, "When I swam at Glen Ivy as a child, the water was so warm it was difficult to swim even the width of pool." (Courtesy author.)

VERANDA AND FOUNTAIN AT TAVERN AT GLEN IVY, C. 1930. "This is where we are staying. It is in the hills with trees all around and the wind blows through the leaves like music to our tired ears," wrote the sender of this postcard. The veranda, pictured here from the outside looking in, reinforces why visitors valued the resort as a tranquil oasis. Activities available included riding horses along mountain trails, swimming, hiking, croquet, shuffleboard, badminton, ping-pong, and tennis. For those less apt to enjoy a high activity level, there was trout fishing on the premises for houseguests only—a license was required. Once guests were worn out, they could then soak in a mineral bath or the sulphur plunge or enjoy a massage or hydrotherapy before lounging on the veranda while enjoying the gorgeous surroundings. (Courtesy D. Talbert.)

GLEN IVY LOBBY, MID-1920S. A coyote, fox, bobcat, raccoon, and three owls, all preserved by taxidermy, are on display as hunting trophies on the river rock and field stone fireplace. Native American artifacts found in the area of the springs are showcased as well. Animal skins and a rug are found on the brick floor. These items undoubtedly encouraged friendly conversation among guests. (Courtesy author.)

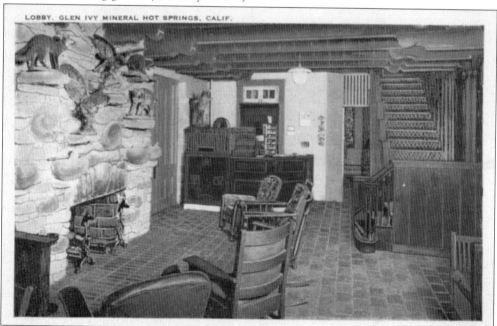

GLEN IVY LOBBY, MID-1920S. The lobby is seen here from a different perspective than above. The fireplace is on the left, however, the preserved coyote is perched upon the reception desk. Also on the desk is a display offering postcards for 5¢ encouraging guests to send correspondence to loved ones and friends. Stairs leading to the second floor are on the right. (Courtesy author.)

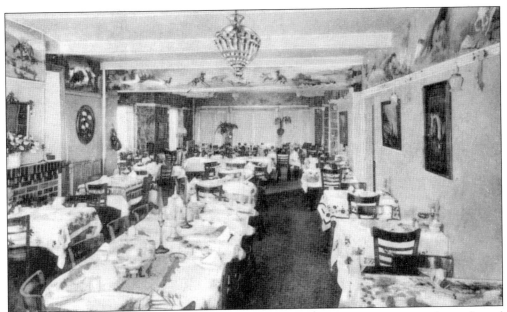

GLEN IVY DINING ROOM, C. 1918. This view of the main dining room shows formal table settings arranged for a hungry crowd. The brick fireplace, centrally hung chandelier, and western-themed murals at the ceiling level combined "the rustic" with formal elements. Commenting on their stay at Glen Ivy, guests wrote, "Up here for a few days, it's beautiful and the meals are delicious." (Courtesy author.)

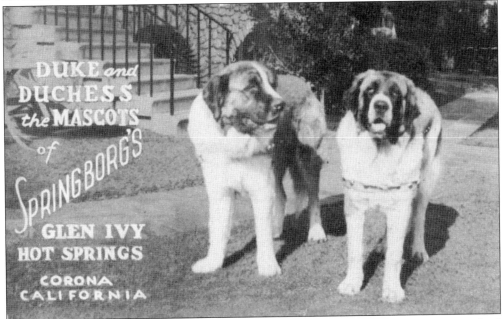

GLEN IVY MASCOTS, 1946. Duke and Duchess were St. Bernards belonging to Axel Springborg, the Danish hotelier and restaurateur who bought Glen Ivy in the late 1930s. Many who visited Glen Ivy during the Springborg era of nearly 30 years recall seeing the massive dogs while on the grounds of the resort. After World War II, he purchased Hotel Kinney in downtown Corona and renamed it Springborg's Hotel. (Courtesy author.)

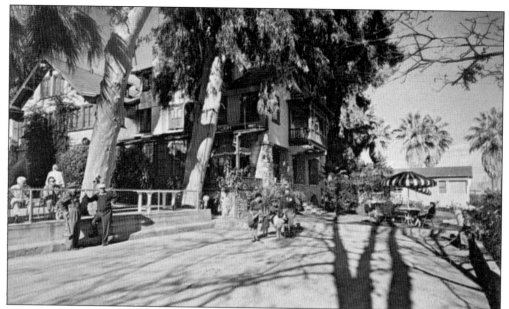

THE TAVERN AT GLEN IVY, C. 1955. Guests were enjoying the glorious grounds and scenery near the hotel or tavern when this postcard image was captured, and one of the St. Bernards is befriending a couple (center). The buffet line was born during the Springborg era. One visitor wrote, "We ate here last night. The food was delicious but I ate too much and got indigestion. They had a smorgasbord there. Everything was so tasty." (Courtesy author.)

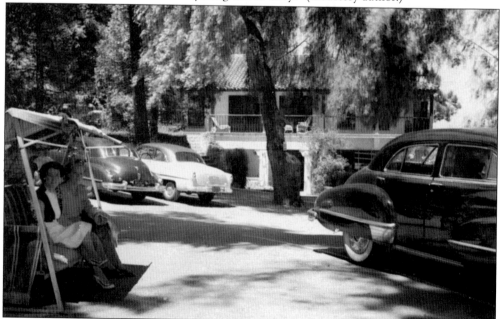

GLEN IVY PARKING AREA, 1956. The sender of this postcard wrote the following about Glen Ivy: "It was a beautiful day to drive down, scenery all the way. Relaxation set in at once." Little concern was given for the establishment of formal "parking lots." Vehicles were parked on flat ground near whatever lodging space was allocated to a guest. Two visitors are relaxing in the canopy-covered swing on the left. (Courtesy author.)

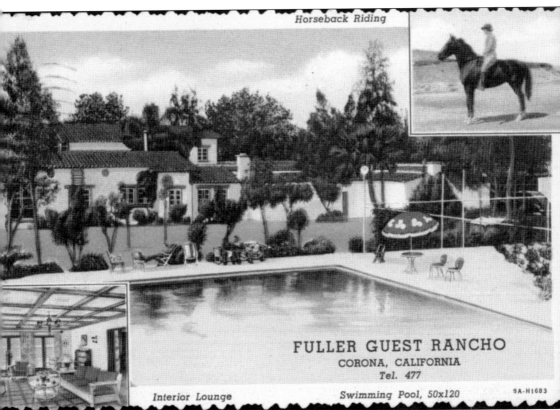

Horseback Riding

FULLER GUEST RANCHO
CORONA, CALIFORNIA
Tel. 477

Interior Lounge

Swimming Pool, 50x120

9A-H1683

FULLER GUEST RANCHO, 1946. Charles H. Fuller, a successful businessman for whom the city of Fullerton was named, bought and developed property after World War I that was once part of the Jurupa Spanish land grant. It was located off Archibald Avenue and had a Corona address. The rancho became the Fuller family's weekend and vacation retreat. The spacious home was built in the Mission/Mediterranean Revival architectural style. Charles sold his Corona land to his son O. R. in 1925. O. R. purchased additional property and leased land in the Santa Ana River bottom until his cultivated acreage totaled about 5,000 acres. This was the largest ranch under one owner in the Corona area. Combining his name with his wife's, Ione, O. R. called their home Casa Orone. The complex opened to the general public for recreational use in 1937, however, in 2004, the County of Riverside permitted the entire complex to be demolished to make way for homes in Eastvale. (Courtesy author.)

RECREATION AREA AT FULLER GUEST RANCHO, C. 1940. This grassy recreation area at the rancho had a variety of activities to choose from, including badminton, ping-pong, and picnicking. Horses were available for trail riding, and lounging in the shade, of course, was always an option. The guests' rooms were located nearby. (Courtesy author.)

SWIMMING POOL AT FULLER GUEST RANCHO, C. 1940. One of the popular activities was swimming in this large and enticing pool complete with a diving board. Comfortable chairs and umbrellas were also available for outdoor relaxation. A contented visitor wrote on the reverse side of this postcard, "Most beautiful, unique place I'll ever see. We had a delicious dinner served in grand style. We spent the evening in front of a huge fireplace." (Courtesy author.)

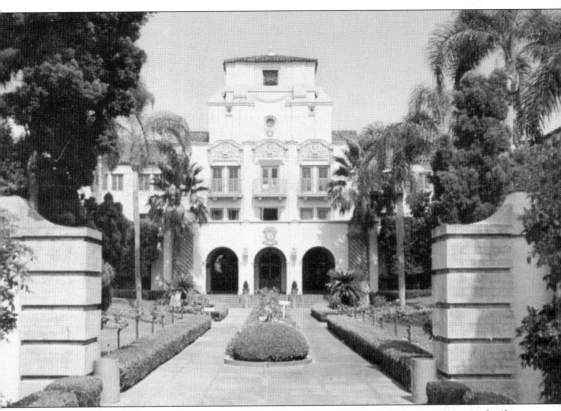

NORCONIAN CLUB-ARCADE ENTRY, C. 1947. The club, a 700-acre luxury resort, was built by Norco founder Rex B. Clark in 1928. Pictured here is the elegant west entrance to the main building designed by Dwight Gibbs of Los Angeles, complete with well-manicured bushes and shrubs. It was frequented by motion picture stars and "A" list personalities. Clark called this the "Bath House" because it had two inside pools. The uppermost window has intricate wrought-iron grillwork. This postcard photograph was taken when the complex was being used as a naval hospital and had a Corona address. The building served as the Administration Building of the Naval Hospital from 1941 to 1949 and again from 1951 to 1957. It has since served as part of a rehabilitation/prison program. The complex was named to the National Register of Historic Places on February 10, 2000. (Courtesy author.)

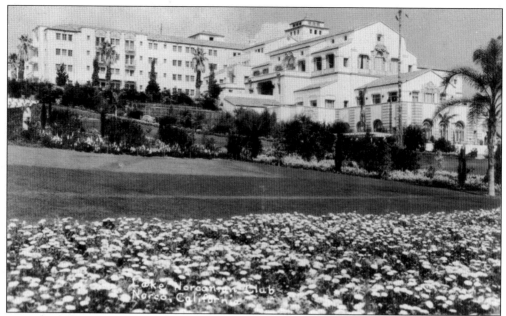

NORTHEASTERLY VIEW OF LAKE NORCONIAN CLUB, C. 1929. Clark lived a luxurious life in Pasadena and wanted only the best landscaping for his club in Norco. According to newspaper accounts from 1929 to 1940, football teams invited to the Rose Bowl on New Year's Day were offered the opportunity to stay at the Norconian Club to prepare for their bowl appearances. Some teams practiced on the field pictured here. (Courtesy author.)

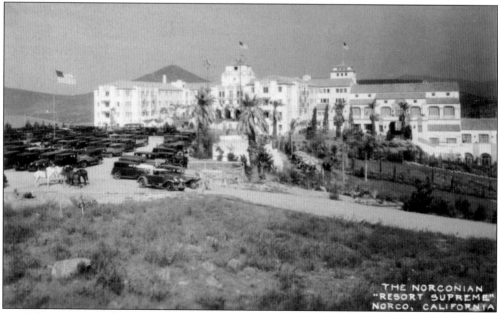

LAKE NORCONIAN CLUB, C. 1929. Rex B. Clark hired Riverside photographer extraordinaire, A. E. Fields, to take photographs to be used to promote the club. This image is thought to have been taken on its formal opening day, February 2, 1929. Three American flags are seen, and cabanas are on the left beyond the parked cars. Striped umbrellas are visible in the center of the image, providing shade for dining guests. (Courtesy author.)

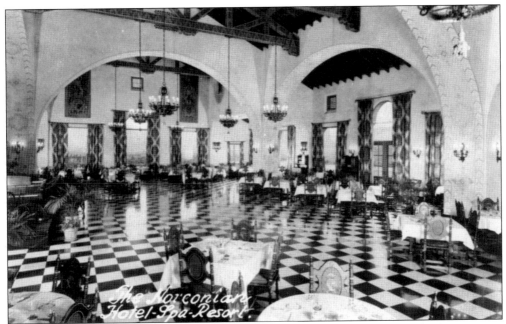

NORCONIAN CLUB DINING ROOM, 1931. The luxurious décor of this expansive dining area was created by interior designer A. B. Heinsbergen. He was recognized as the preeminent designer of the greatest theaters on the West Coast as well as a muralist. The Pantages and Wiltern Theaters in Los Angeles are examples of his work. Checkerboard tile flooring undoubtedly was used as a dance floor at one time. (Courtesy D. Talbert.)

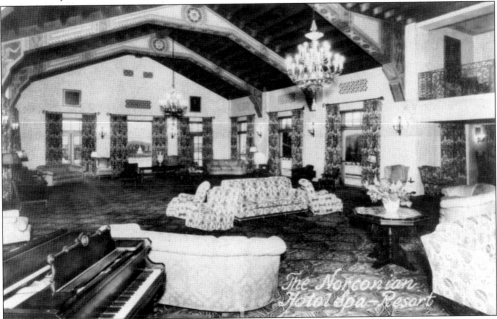

LOUNGE AT NORCONIAN CLUB, HOTEL SPA, 1931. The first-class nature of the hilltop oasis is exemplified here in the rich brocades of sofas, chairs, and tapestry-like carpet. An elegant chandelier and other appointments added to the ambiance of the many gala affairs in the past. There is decorative artwork on the beams and on the ceiling. (Courtesy D. Talbert.)

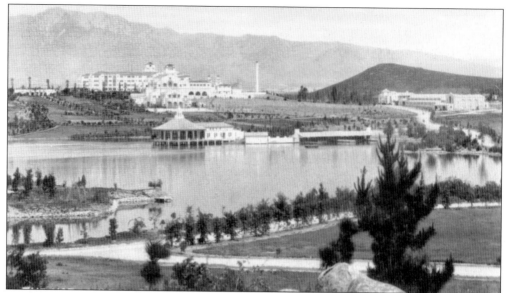

NORCONIAN CLUB, 1929. Sitting atop a knoll, the hotel had a commanding view of Lake Norconian and the surrounding countryside. Buildings at the top of the ridge, from left to right, are the Tea House, the main building, a powerhouse (with smokestack), and servants' quarters. The Pavilion is at the center with the Boat House to its right. Beacon Hill is seen in the background. The sender of the postcard reflects, "Here for a swim. It's some hotel here." The same view is seen on the opposite page. (Courtesy author.)

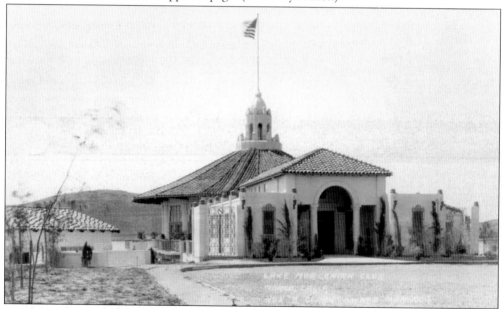

NORCONIAN CLUB PAVILION ENTRY, C. 1929. The Pavilion hosted a multitude of dances, fashion shows, proms, and other social activities over the years. This postcard came from a photograph in an early promotional brochure. Riverside architect G. Stanley Wilson designed the Pavilion, Tea House, women's dormitory, laundry, garage, and gas station. He also designed Corona's second high school at 815 West Sixth Street, the library wing at Jefferson Elementary School, and portions of Riverside's Mission Inn. (Courtesy author.)

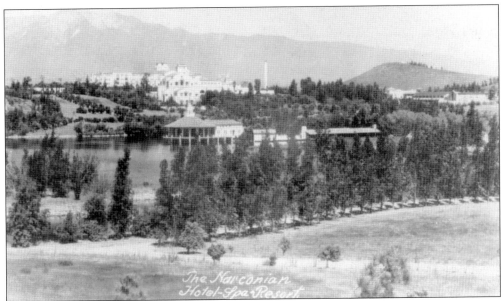

NORCONIAN CLUB, 1939. The Norconian Club, a 700-acre luxury resort and playground for the rich and famous, cost $4 million to construct in 1928. Among its amenities were a golf course, a 55-acre man-made lake, a gambling casino, a tea room, an airport, a hot sulphur spring spa, two inside swimming pools, and a magnificent five-story, 120-room, five-star hotel. After Pearl Harbor, the navy removed furniture, painted over murals, configured offices, and turned the elegant club into an efficient hospital to treat the ill and wounded. (Courtesy D. Talbert.)

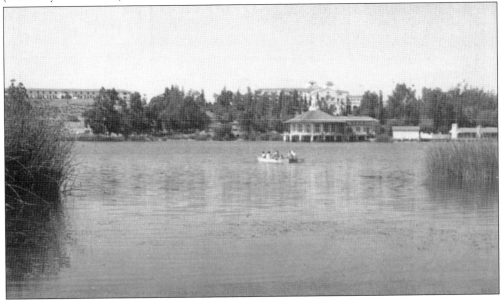

LAKE AND PAVILION AT NORCONIAN CLUB, C. 1943. This view across Lake Norconian shows the circular Pavilion in the center with the Boat House to the right and the hotel, a U.S. Naval Hospital in 1943, behind and above the trees. Two rowboats are seen in the center on the lake. Activities on the lake included rowing, sailing, motorboat racing, fishing, and aquaplaning. (Courtesy author.)

NORCONIAN CLUB SWANS, C. 1939. This postcard's intent was to entice visitors to visit the resort to improve their health, enjoy relaxation, and receive spa treatments, all amid the flora and fauna at the hilltop resort. Without doubt, there were other flying creatures enjoying the good life at the Lake Norconian Club. (Courtesy author.)

U.S. NAVAL HOSPITAL ENTRY GATE, 1956. This view was taken from inside the property and shows the main entrance gate to the hospital as it appeared 50 years ago. While the entry gate is located on Fifth Street and remains much the same today, the two-story buildings on the right were razed in the early 2000s. The peak of Beacon Hill is visible in the background. (Courtesy author.)